Photographing Children and Babies

How to Take Great Pictures

Michal Heron

ALLWORTH PRESS
NEW YORK

To my family:

Bob, Theo, Reyna, Edith, Fran and Michael, Keith,

Emily, Sara, Paul and Jennie, Katie, and Molly.

© 2005 Michal Heron

09 08 07 06 05 5 4 3 2 1

Published by Allworth Press
An imprint of Allworth Communications, Inc.
10 East 23rd Street, New York, NY 10010

Cover design by Derek Bacchus
Interior design and typography by Sharp Des!gns, Lansing, MI

All photographs not specifically credited here or under the photograph are © Michal Heron. Some photographs were provided courtesy of family members. Thank you to Susan Enyart for the photos in 4-1c and to Carol McCutcheon for the photos in 6-2a and 6-2b.

ISBN: 1-58115-420-8

LIBRARY OF CONGRESS CATALOGING-IN-PUBLICATION DATA
Heron, Michal.
Photographing children and babies : how to take great pictures / Michal Heron.
p. cm.
Includes index.
1. Photography of children. 2. Photography of infants. I. Title.
TR681.C5H47 2005
778.9'25—dc22
2005010280

Printed in Thailand

Contents

Acknowledgments

Thanks are due to all the people who contributed so much to making this a better book. To Nicole Potter-Talling for insightful editing, Monica Lugo for adroit placement of photos and text, Derek Bacchus for the appealing cover design, Michael Madole for skillful promotion, Nana Greller for her imaginative publicity, Cynthia Rivelli for never letting up on the marketing, Charlie Sharp for his design, and of course, Tad Crawford, publisher, for unending patience and making it all possible.

My grateful appreciation goes to the all the children and their families who allowed me to photograph them. A special pleasure came from photographing the *second* generation and including them in the book. Thank you to Keith and his *Emily and Sara*; to Jane and her *Petey and Darcy*; to Ted and his *Willie and Charlie;* to Greg and his *Jessie and Ryan*; to Betty and her *Gloria, Marc, and Pau.*

Finally, thank you to Theo for his enduring patience over all the years of photography.

There is nothing in photography to equal the joy of getting a good portrait of a cherished child.

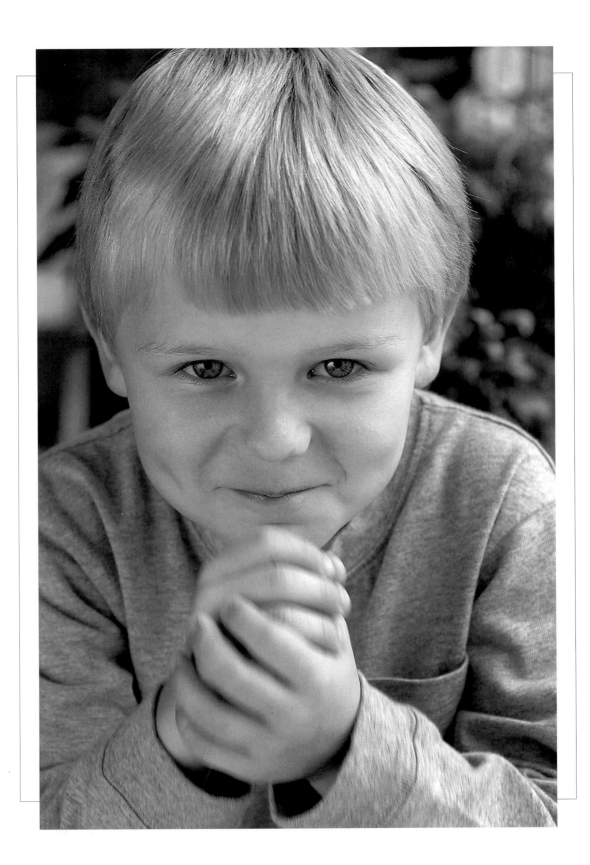

Seeing Your Children

W.C. Fields may be the only person who ever went on record as disliking children. For most of us, babies and children are endearing creatures and the most appealing subjects for photography, ever. The world is full of parents, grandparents, aunts, uncles, and close friends who yearn to get pictures, lots of pictures, of the children they love. Many of you are delighted with the photos you take, because your mind and heart are seeing, captured on film, your beloved child. What you may not be seeing is the actual photographic quality of the picture. I've had proud parents show me snapshots over which they gush with delight because the child in the photo is their child—never mind how small, shadowy, or out of focus the image. They don't see that the photo itself is not doing justice to the child, and it's easy to remedy the problem.

There are those who notice a quality difference between the lukewarm image that ends up on film and the enchantment of the real child. Frustration is the lot of those parents who realize that they haven't captured the energy, appeal, and personality of their little ones. They long for good photographs that truly express the charming individuality of the child.

Helping you see your children through photographs, the way you see them in life, is the goal of this book. You will learn to make photographs that show the genuine child, capturing an authentic range of emotions and spontaneous moments that show delight, puzzlement, affection, and even irritation or stubbornness. To do this, to find the unique personality of your child, we won't suggest cute or contrived setups with costumes, gimmicks, or stiff poses, as these usually result in artificial photos. Every chapter will work toward your goal of providing photographs that truly reflect your child.

The book will give you the information and techniques needed to make dramatic improvements in your photos without, in most cases, major equipment purchases or photographic training. What you need is the determination and the willingness to be disciplined in your photographic approach.

The early chapters of this book concentrate on different approaches to taking children's photographs, tips for finding the best backgrounds and lighting, and ways to plan your photography to get the best results. Except for an occasional reference to equipment, the technical aspects of photography will be covered in chapter 11.

These methods for improving your photos of children will be effective even if you stay with the simplest point-and-shoot camera. The topics covered will improve all your photos even without dramatic upgrading of equipment—they will point you to a new style of shooting.

Some styles of child photography, such as extreme close-ups, will require a camera lens that can provide sharp focus when used close to the subject. You may not have that capability in your current point-and-shoot. But the lack of this lens shouldn't be a major impediment. You can concentrate on the other types of photography described in the early chapters of this book. Then, when the hunger for close-ups grips you, you'll upgrade to a better camera and lens. When you do, you'll find a wide range of cameras available today in a moderate price range, so an upgrade shouldn't be a major obstacle.

Digital Versus Film

The same good results can be achieved with digital as with film. There are pros and cons to each, which will be explained later. If you are unhappy with your current system and want to change, then before embarking on this new venture, by all means, skip to chapter 11 and investigate the relative merits of film and digital. As a convert to digital after many years using film, I would probably steer you in the direction of digital, but it is not essential to getting good photographs. Film has done a proud service for more than a century, and can continue to produce fine photography for you if that's your choice.

You can certainly continue with whatever camera system you've been using while you put into practice the precepts of style and practical approaches to children's portraits outlined here. While doing so, you might gain insight into the type of equipment that suits you best.

Terminology changes with technology. From many years of using film, I may use the word film, as in shooting enough "film," or getting the shot on "film," but I'm not expressing a preference for film over digital. When I say film, I simply mean images. We are talking about pictures, photos, images, regardless of the method of getting those images. Whether you end up with photographic prints, color slides, or prints from digital files, the proof of the pudding is in the resulting picture.

Snapshots or Portraits?

The distinction between a snapshot and a portrait isn't one of snobbism and doesn't carry any value judgment. It is simply a matter of expectations balanced against the effort you've put in. Don't feel that, when you begin a serious attempt at fine baby and children portraits, you must give up snapshots. You can do both. Snapshots are wonderful. They free you to shoot without thinking and with almost no effort. They usually don't yield the quality of what you can get with a serious effort at portraiture, but they are well worth having.

I love taking snapshots. Recently, as a birthday treat, I took a family member to the dog show at Madison Square Garden. We shot snapshots with a disposable camera. It was

perfect. We were unencumbered, yet pleased to be getting enough pictures to show the rest of the family what we had enjoyed seeing: the dogs, the handlers, and the backstage area. We weren't trying for fine portraits of the dogs or reportage of the Kennel Club scene. We were simply grabbing snapshots—and it was fun!

Actually, sometimes a snapshot can be indistinguishable from a portrait. Once you have practiced your skills at portraiture, you may find that your grab-shots have improved to the point that serendipity and quick thinking will provide a terrific portrait/snapshot. It doesn't matter what you call it if the results are good.

Instead of thinking of good or bad snapshots, or good or bad photos, I'd rather consider whether a photo is successful or not. That's not just newspeak from the world where people never have problems, only challenges. I think it's a truism that a photo of your child can never be bad. But, the question "Is it successful?" can be answered. Did you catch the expression, mood, or movement you were trying to record? My rule of thumb, and a safe way to critique at least the face shots you have taken, is to ask: Can I see the expression in the eyes?

Planning Photo Sessions

As with most beginnings, it's good to start with a plan. If you intend to set about a serious photographic coverage of a child, then having an organized approach will greatly increase your good results.

That doesn't mean you won't take advantage of luck and, when you see a wonderful moment, grab the camera and take a picture. You will do that. But you also will *plan* photo shoots almost in the same way a professional would—by setting aside time, getting your equipment together, and creating or finding a good location and lighting. Finally, you'll decide on the style you want to try that day—and start shooting. Each time you organize a "photo shoot" with your child, you should have a goal for the style of pictures you want. Try creating photo assignments for yourself based on each chapter of the book. Use the topic of the chapter as your assignment. Make an effort to shoot at least one specific assignment each month in addition to any day-to-day photography you do.

The approaches and styles introduced will help you plan your shooting day. For example, one day you may concentrate on close-ups of the face, choosing a suitable location and wardrobe. Another time you may try showing the child in action, outdoors playing a game; or you may plan coverage of the intense concentration a child shows while working on a craft or assembling a toy or puzzle.

Babies and children are unpredictable, so much of your success will depend on the age you are working with and the mood of the child that day. Babies and toddlers, if they are dry, well fed, not teething, or needing a nap, may be enticed into most any location you want. Older children may not follow your plan and are likely to present their own ideas of what they want to do or where you should photograph them. But having a plan gives you a departure point. Even just following a child as he wanders the backyard can be a plan for one of your shoots. The one sure thing is that having a plan, in the long run, will result in more good photos than just shooting random moments. The discipline of following a plan intensifies the experience and helps you to learn. Keep in mind that professional photographers base their careers on this kind of discipline—it's called "making the shot happen," and requires diligence every bit as much as talent and skill.

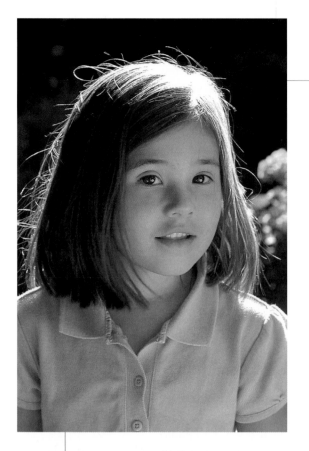

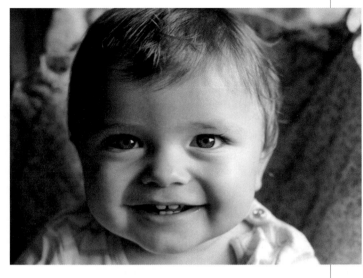

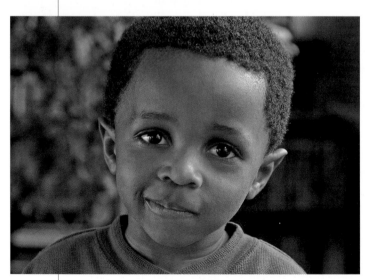

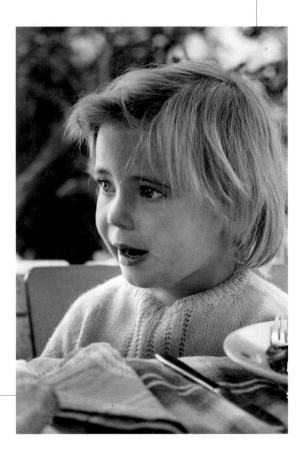

[1-1] Work toward taking intimate photos of the child showing a full range of authentic emotions. Capture the subtle changes in expression and all the endearing little quirks you see in them every day. You'll cherish those expressions just as their parents do in these photos of Jessie, Marc, Jevon, and Betty.

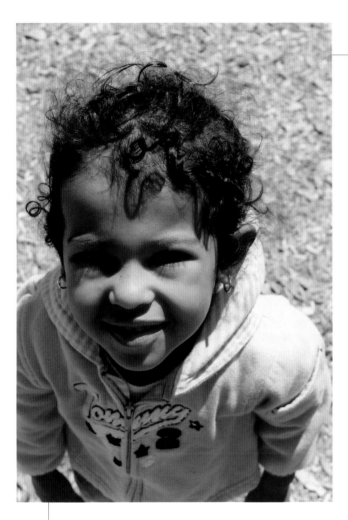

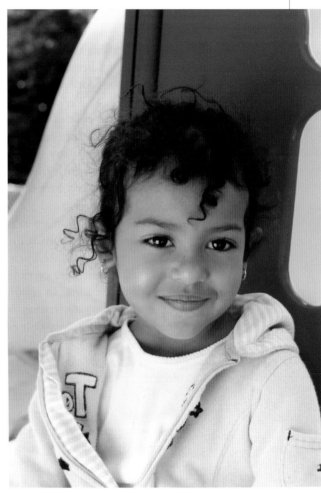

[1-2] These two photos of Skylah were taken at the same time and place in the same clothes. Can you believe it is the same child? The photo on the right is clearly more successful. The differences between the two photos highlight the major points in this book: light, background, and lens used. The left-hand photo was taken in harsh sunlight, shot looking down with a wide-angle, 35mm lens into a glaring bright background. In that photo, a less-than-successful snapshot, you learn almost nothing about the child. You can't see the expression in her eyes. At right, she is in open shade, which nicely shows her eyes, and was photographed with a 90mm lens against a simple colorful background.

Expectations

Depending on your relationship with the child, set realistic expectations of what you can achieve for each shoot. Use each opportunity with the child to take a certain type of photograph. You can be flexible, depending on the circumstances, but when assigning yourself a plan ahead of time, take into consideration the amount of time you are likely to have, the conditions you'll encounter, and your ability to control those conditions.

For example, if you are a grandparent on a family visit, you might be able to control your photography to the extent that you can position your grown son with your toddler grandson on his lap, in open shade, on a porch, reading together. You can work for close-ups of the toddler engrossed in the book, or an endearing interaction between father and son. That will work as long as the baby isn't bored with the activity or your son/collaborator isn't pulled away to a conference call. If you are a parent, by working alone with your child you have control and some excellent opportunities for photography. But don't ignore the value of assistance from the other parent, partner, or an older sibling. It can be very good to have a helper ("baby wrangler" is the term in the profession), either to be a model actually in the photo with the child, or to help distract or assist. Your partner's shoulder, upon which a toddler can be perched, or a lap where the baby can be safely contained are very useful, safe locations.

Consider who you are as the photographer, i.e., your relationship to the child, and what advantages or limitations it brings to your job as a self-appointed chronicler of this child's life. Are you the parent? Then your great advantage is that you spend lots of time with the child. You are there, at every time of day, in every season, and at many locations whether at home or on vacation. In addition, the child is totally at ease with you. The drawback to the parent as photographer may be that you are exhausted and harried by a hectic life, which keeps you busy coping with career, home, and child-rearing. If the images are important to you, then set aside time on a consistent basis for photography. Once a week for two hours. Or every day for a shorter time. Just don't let those months and years slip away without a record.

If you are a visiting grandparent, aunt, uncle, or family friend, your advantage may be the novelty you present to the children. Oftentimes, someone they don't see on a daily basis can catch their imagination for a brief period, just enough for some terrific photographs. For example, if you are the grandparent of a toddler who is fascinated by your tractor lawn-mower, then perching that child behind the wheel (motor turned off, naturally) could yield some delightful, exuberant expressions. Anything special you do on your visits, especially if you get the child alone, will provide photographic possibilities. The bonus is that your photographic bond can build an even richer relationship with the child. The disadvantage is that your time with the child may be limited, or you may be around the child when the situation is fraught with other activities.

Back to the idea of planning. Since your time with the child is probably limited, you can make that time produce the best photographs if you think ahead about what you want to try to photograph. If you are going to babysit the child during a quiet afternoon, you can plan some setup portraits with your young nephew or niece. However, if it is a busy weekend with relatives gathering for a barbecue, you may not be able to do more than try to catch the child in action.

The Gift of Photography

Early in my career as a professional photographer, almost by accident, I discovered the value of photography as a gift. I was visiting close friends who had a three-year-old daughter whom I'd never met before. Each dawn she came to wake me, curious about this new friend visiting her family. She would offer to show me the treasures of her house and nearby woods—her tree, her kitten, her doll—her world.

We spent several quiet early mornings together taking walks or sitting on the veranda in the fresh summer light. I got some unguarded moments that became photographic treasures to her parents. The photography was a joy unto itself, because the child was lovely in the morning light, but additional pleasure came later when the parents saw the photos. Parents have often remarked that photos of their children were as good a present as they could receive. It's nice to have that gift to offer. You may find that in addition to recording your own child, you will be able to share your skills and give a very special present to friends or relatives—photos of their child.

The Child's Attitude

Some children will accept your constant photography as a part of their daily lives, responding to the camera with cheerful indifference. At some point they may learn to "ham" for the camera, in an effort at what they see as cooperation. At these times, it's wise to take the posed shot as offered. Let the child participate. Then work to find some activities as a distraction from your lens—ask him to tell you a story, or to point out a favorite tree, flower, house nearby. This may get the mood or spontaneity you wanted. Also, letting a child ham it up for the camera can be a form of payback instead of a one-way street, with you taking and the child giving.

Try not to wear out the child to the point where photography becomes a nuisance. Children can pick up on, and resent, a truly intrusive manner when you are photographing. They can sense a greediness on your part. Or, even if you are delicate in your approach, they may simply tire of the photography and express temporary irritation at the process. There have been moments when, to my mortification looking back on it, I realized I was taking advantage of a child's good nature in pushing him past what he wanted to give. If you sense you are overdoing it, let it rest. Back off for awhile.

At a certain age, children may want to take pictures of you, or at least look through the camera to see what fascinates you so much. Letting them take a few snaps may result in some wasted film (or space on your digital card) and yield blurry photos of the cat or the edge of the porch, but it's only fair to let them participate. Involving them may provide an antidote at the moment they express exasperation with the photographic process. There must be a two-way street, or what seems like simple photography could border on exploitation.

Reportage

Think about the photography project of your child as a reportage, an ongoing coverage, similar to what a photojournalist or a documentary photographer does. That may help you build the mind-set needed to create a long-term record. Any manner of thinking that will help you make a plan and stick to it is invaluable. Many pressures in a busy life compete for our time

7

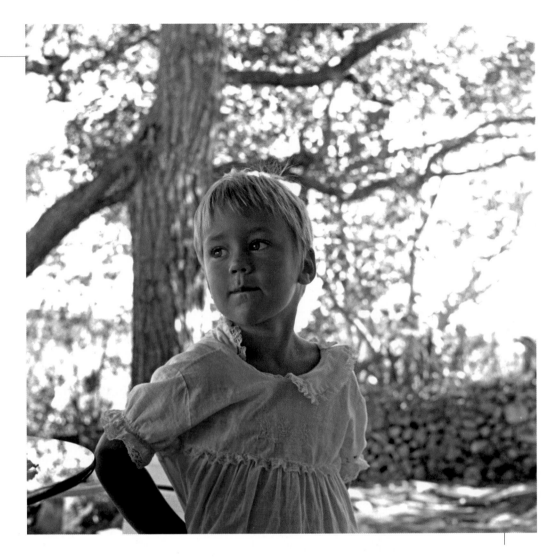

[1-3] This photo of Jane, part of a large group taken on several successive mornings, became a fond memento for her parents.

and attention. But don't consider photography of your child as a luxury, last on the list. Much is made of the value of quality time with children. Quality photography fosters and enriches your experience with a child. And you have the photographs as a bonus.

Legacy

By following the guidance in this book, you will be able to capture the moods, the growth patterns, and the emerging personalities of your favorite children in images that will be a delight for everyone in the family. Remember that when you document children's lives, you create a legacy for them as well as for their own children.

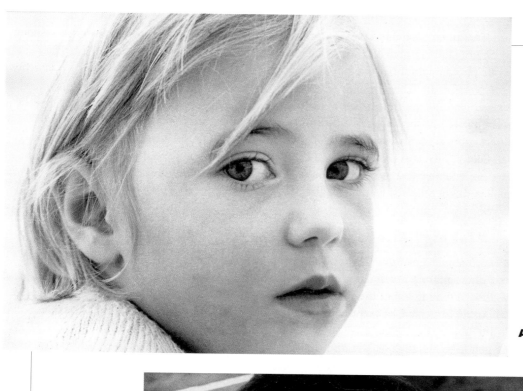

A

B

[1-4] Betty loves the high-key photo of herself at age two and a half (A), taken in front of a blanched white wall in the Spanish fishing village of Nerja. Years later, I was pleased to photograph her own daughter (B).

That point hit home when long-time friend Betty Arribas, now a young mother, asked me to photograph her new baby girl. She wanted me to use the same high-key style of black-and-white photography I had used in a portrait of her, taken when she was a toddler over twenty-four years before. That early photograph had been intended for her parents' enjoyment. What I never realized was that, growing up, Betty had always treasured that particular image of herself. Apparently, she had responded to the impact of the extreme close-up, the stark light, and direct expression. She wanted a similar style of portrait, another heirloom-to-be, of her daughter, Gloria. That was the first request she made when she introduced me to her child.

So, whether you are the parent, a relative, or family friend, it may be years before you realize the depth of the gift your time and photographic effort have created.

"Taking" Photographs

A word about semantics. Through the years, there has been an undercurrent of discussion in the photographic community about the terminology, sometimes aggressive-sounding, that we use in talking about the photographic process. We speak of "shooting" a photograph, of "shooting" a person, of "capturing" an image, or at the very mildest, "taking" a picture. Some in the photo community have suggest that we try to school ourselves to using more neutral or gentle terms, such as "creating" an image or "making" a photograph. I will try to avoid overusing the word "shoot," since it is even more offensive when it appears in the same sentence with "child" or "baby." But it might become awkward and contrived to avoid it altogether and speak only of *making* photos. Also, it's hard to break a habit of thirty years. So I beg your indulgence in the use of photography language.

Photo Illustrations

In every chapter of this book, there are sample photographs to illustrate the concepts being taught. Often, perhaps to the point of overkill, you will see both successful and unsuccessful photos of the same child in the same location. Further, I will show some rejects—that is, photos that don't quite work. You'll see some of my mistakes, as well as examples of what are good (oops, I mean "successful") photos. This should help you make the distinction between photos that are smashing, merely ordinary, or just plain boring. I've included this variety of photos, since I believe the easiest way to learn and teach a visual form is by doing it visually.

The sample photographs include images made over many years, as well as some photographs taken specifically for this book. In the photos taken to illustrate the techniques for this book, I've tried to use only the equipment or lighting that would be readily available to those with a basic or intermediate level of photography experience. In most cases I've avoided using the full professional strobe lighting, which produces perfectly lighted portraits, since many of you won't want to get involved in the expense or trouble sophisticated lighting entails. It doesn't seem fair to show you photographic results achieved using thousands of dollars worth of equipment. I will identify the few photographs in this book made with professional strobe lighting.

However, for the professional photographers or serious amateurs who read this book, you already have extensive equipment. You can benefit from the approaches to child photography in these chapters and still utilize your sophisticated equipment.

Finally, I admit that I am steering you toward my preferred style of child photography, which is as candid and genuine as possible. I lean away from the nostalgia style of children's portraits, with its romantic props and settings. There are many child-photography books that feature children in straw bonnets holding flowers, in Victorian costume, and with heavily diffused lighting. Those of you who find this charming can easily adapt the precepts in this book, then simply add your own sense of propping. Some friends in Florida take photos of their twins in holiday costumes representing each month of the year. They range from St. Patrick's Day leprechauns to autumn leaves. It's a family activity they enjoy, with the propping, making costumes, and photography. My goal is to help you capture images of your children as you know them, but the final decision on style is determined by your taste.

Seeing Your Children

In this book I will speak of "your" child, or "your" baby, but I don't mean the terms to infer a blood relationship. The bond with a child can be profound and put hooks deep into your heart, whether you are the biological parent, an adoptive parent, a stepparent, a grandparent, or a family friend. The feeling you have for a child, or the depth of a friendship you have with the parents of that child, can be intense and will show in your photography.

So let go with your passion and get ready to take wonderful photos of those dear creatures. Seeing your children on film the way you see and cherish them in reality is a satisfaction that deeply enhances your privilege in being part of their lives.

BASIC FOUR

Even with the many sample photos and pages of specific information you'll find, there are a few simple guidelines to take away from this book. Whatever your equipment or experience level, these four precepts will be the most effective in improving your photographs:

▶ Take photos that are close up
▶ Photograph in a gentle, soft light
▶ Use a "clean," nondistracting background
▶ Vary the mood by capturing many expressions, including serious or thoughtful, not just smiling

The Value of Shooting Close-Ups

One of the best tips I got early in my career was from an art director. When I asked what style he needed for a new project, he said he wanted images that were "Close, closer, closest." The single greatest failing of most amateur photographers, especially when photographing children, is that they do not go close enough to their subject. It's understandable that someone unaccustomed to photography sees the subject with his or her eyes only and not through the camera lens. During the process of taking the picture, it's easy to ignore the extra space around the subject—that is, until you see the final photo and only then realize how far away the subject is and how difficult it is to see the face. It is easy to forget that the camera records everything in front of the lens and can't zoom in unless you make it do so.

The human eye has an advantage over the camera: It can perceive several parts of a scene simultaneously. At a distance of five feet, your eyes and brain can see and interpret your child's face as a super close-up while maintaining a peripheral awareness of the space and details surrounding the child. The camera is limited to what shows through the lens you use—at whatever distance you choose. If you leave a lot of extraneous detail on the perimeter, your child becomes only a small element of the scene. Looking critically at your own photos will help you recognize when your child is too small in the photo. But this will work only if your perception and judgment are not clouded by the simple fact that the tiny figure is your child. Avoid the denial factor. Don't deny that you may have a photo with minimal impact, especially when much stronger photos are possible.

Why Go Close?

Intimacy is what most people cherish with a child, whether that child is their own, a grandchild, a nephew, or a friend's baby. You can almost never shoot photographs that are *too* close up. Getting close gives immediacy to a photograph. It approximates the experience of being

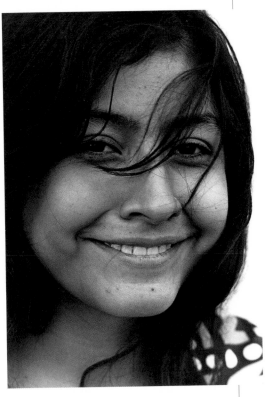

[2-1] A close-up can be a super-tight shot framed from eyes to chin, or it may be a full-head photograph. The significant aspect is that a close-up should make you feel a strong connection with the child. These teenagers were photographed with different approaches and lenses but both photographs achieved a close-up feeling. I told Grant that I wanted to work close up with a close-up lens (since his mother is a photographer, he was thoroughly relaxed about it). I took Maria's photograph with a short telephoto, the classic 105mm portrait length.

with a child. Have you noticed how often adults put their faces right up to a baby when they "gootchy goo" and talk baby talk? The natural inclination is to go "close, closer, closest."

As children get older, you must respect their individuality and give them more physical space. However, the impulse to be close is still there. Surreptitious hugs and hair tousling may replace your earlier ways of expressing affection, but fondness still impels you to go close. When photographing a school-age child or even a teenager, you must use other ploys (and lenses) to get close. There will be tips later in chapter 9 on techniques for photographing different ages.

How To Shoot Close-ups

There are two ways for you to achieve your close-ups. One is to bring the camera close to the subject, moving in tight, using a close-up lens designed to give sharp focus at a close distance. Sometimes called macro or micro lenses, these lenses allow you to shoot to within inches of a subject.

An alternate method for shooting close-ups is to move back and use a telephoto, or "long," lens. This brings the subject close without your having to be nose to nose with it. There will be more about lenses in chapters 6 and 11.

I find that most babies don't mind having the camera in their faces. They are often amused or intrigued, which can give you wondrous shots. (However, when working close do be wary of sticky fingers reaching for your lens.) Babies and toddlers can be especially charmed if you take your time getting them used to the process by bringing the camera close to their faces, engaging them in a playful way. They may look right into your lens with a gurgle of delight, a serious gaze, or a puzzled look of inquiry. All of these expressions are worth recording.

Older children may be less kindly disposed to having a camera pushed in close to them. Unless you have a very good relationship with the child or teenager, you may want to work with a telephoto from farther away. If you want to work close with a lens, you could explain to a teenager, if you have a good rapport, that you are experimenting with a new lens, seeing how it works shooting close, and ask if she will help you. If that is what you are actually doing, then your comments will have the additional merit of being true.

Framing or Cropping

Another way of creating a close-up, somewhat through the back door, is by cropping a photograph later, after you've finished the photo session and can't do any more shots (perhaps because your subject is down for a nap). First a look at the terms:

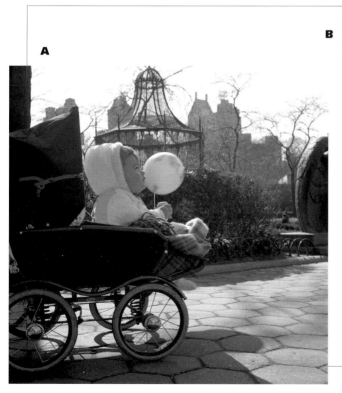

A

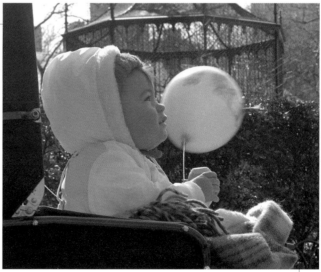

B

[2-2] The full image (A) of Greg with his balloon was shot at the Central Park Zoo. The full image is boring, with too much space given to the wheels of the stroller, and very little emphasis on the baby. The awkward framing ends up pulling your eye away from the child. The cropped version (B) is an improvement.

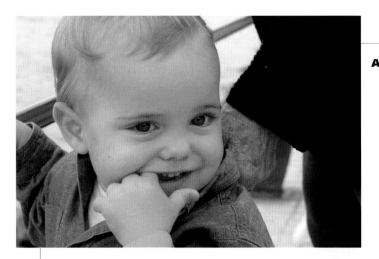

A

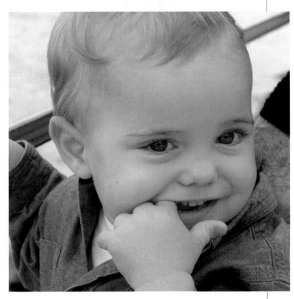

B

C

[2-3] What you see in the full "snapshot" version (A) is sweet—Paul's finger in mouth, his grandmother's hand holding tight so he doesn't slip off the wharf into the water. But in the close cropping they just become peculiar. At first, it looked like photo C might work, but by then the enlargement is too great and the photo becomes fuzzy. Photo B appears to be most successful.

Framing is the process of selecting what you want in the photograph at the time you are taking it. Also known as composition, or composing a photo, it is the decision of what you show in the viewfinder and ultimately in the frame of the film (image). When you take a close-up photograph by looking through the lens and moving the camera so you see the full face of the child, you are framing, or composing, your close-up.

Cropping is using only a part of a photo, not the full frame that the camera saw and recorded as the image. You might crop a photo to cut out a distracting detail or to improve the composition. In our current context, cropping is used to create a close-up after the fact. If you weren't able to get close, or forgot to move in tight, the result may be a nice picture that is just a bit too distant. In that case your solution may be to crop the photo. Cropping is a perfectly valid way to achieve a close-up.

The success of cropping usually depends on the sharpness, as well as on the resolution and graininess of the original image. When you crop you are blowing up (enlarging) a

16

A

[2-4] Among these three photos, it seems clear that the close-up in photo C has the strongest impact. It has the additional benefit of minimizing the distracting (and annoying) tree and playground equipment behind Christopher. Remember that when you look at a scene, your eye and brain may have photo C in mind, but unless you are working close or using a telephoto lens, the camera lens actually sees not just the child's face but all the peripheral details that are in photos A and B.

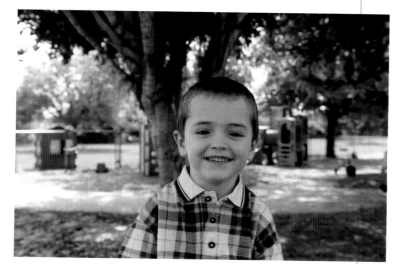

B

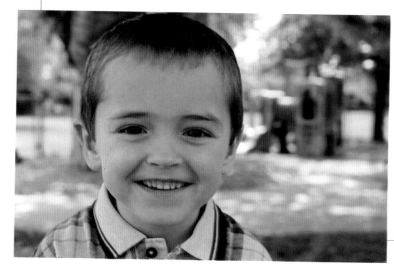

C

portion of the original. It will almost always mean sacrificing some sharpness. If the original is "tack sharp," then the cropping should be fine. If the full image is a bit soft—that is, slightly out of focus—then your cropped version will be softer yet. How successful that cropped photo turns out is debatable.

The Central Park photograph of Greg in 2-2 is vastly improved by cropping. I have no excuse for not going closer. We were walking along, he looked up, and I took the picture from my vantage point, which was just a little too far away. I had not been prepared for a close-up. The cardinal rule is always take the shot even if conditions aren't perfect. You may be able to salvage something, but you can't recreate in the lab or on the computer the sweet expression on your subject's face.

Cropping is helpful for more than just rectifying a mistake. It can be used also for creative effects. Generally I prefer fairly simple cropping and framing in pictures of children since they are the magical element. But if your taste is for the dramatic, then crop accordingly by enlarging portions of a photo for a bold or striking display presentation.

When Cropping Doesn't Work

There are times when you have to give in and admit that cropping won't save the day. In the photo of Paul with his finger in his mouth (2-3) I tried cropping various ways and nothing worked, mainly because the photo was not sharp enough to enlarge. I got hung up on the nice expression in his eyes and tried, to no avail, to crop so they would stand out. But I couldn't get rid of the awkward elements without enlarging the image beyond decent quality—you can see how blurry the eyes become in the extreme blow-up. The original isn't sharp enough to stand the enlargement. So, viewed as full frame, it remains a nice snapshot but not an outstanding portrait.

How Close Is Too Close?

In my view, nothing is too close. Even if you are hesitant, trust me and just try going in super-tight on your child. Cutting off part of the head is not a hanging crime. When done to achieve immediacy, tight framing doesn't hamper the picture but promotes the very intimacy you are seeking. The key is not to have it feel accidental. If you look at a photo and wonder where the top of the head is, then perhaps you have framed it awkwardly. If you look at the photo and feel pleased by what you see, then the framing is successful. Proximity breeds contempt only with annoying adults. With children, it forges a bond that the photograph preserves so well.

For those who are uneasy about framing photos that cut off the tops of heads, try this experiment. Take some photos of your child with the full, rounded head showing. Then go close up, just cutting the round part of the head. Next go in very tight, framing from the forehead to the chin (lens permitting). I suspect you'll agree that the intimacy you get makes all other concerns fade away. You'll see variations of framing in this chapter.

"Eyes Are the Window to the Child"

If you will forgive the paraphrase above of the saying that the "eyes are the windows to the soul," it does hold true that in close-up photography of children, featuring the eyes adds an

18

[2-5] Getting close was accomplished with different lenses in these two photos. Above, a 60mm macro lens was used, and the shot was taken just about twelve inches from baby Charlie's face. At right, Tim was taken from a distance of about twelve feet using a 135mm telephoto lens.

extraordinary impact provided by few other styles of photography. As you'll see in later chapters, there are many other types of photographs worth taking of your child: action, silhouette, and full-figure angles. All of these make appealing pictures. However, when you are building a photo record of your child, the foundation is made with close-ups showing a variety of expressions in the eyes.

Look at the photograph of baby Ryan in photo 2-6. It appears to be a simple photograph of a child looking at the camera. But do you feel as if you could drown in those trusting eyes? If I'm charmed by the photo, imagine how his parents feel looking at it? If this photograph of a stranger's child moves you, trust me, you will be overwhelmed when you have a photo like this of your own dear one.

Looking Away

Frontal photographs, the ones with the child facing you, are just the beginning of your close-up photography. It is the natural way to begin to think "close up." Frontal photos are the classic way of making a child's portrait, often with the advantage of having the eyes looking directly at you. Though they might even seem trite, when taken with good, clear focus they remain as powerful as any images you can have of your child.

But once you have success with frontal-face close ups, with the child's eyes looking to

19

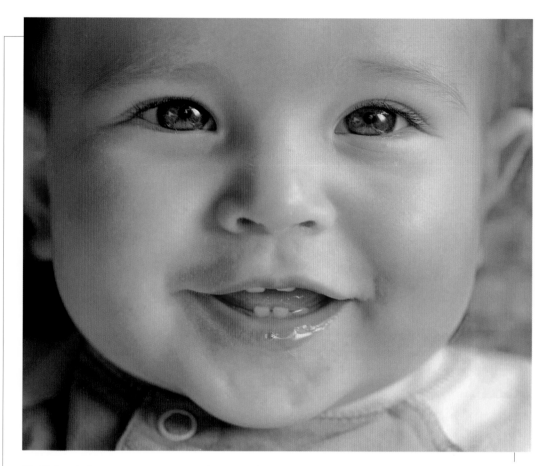

[2-6] Ryan's joyous expression, complete with drool, is more powerful in this close-up than it would be in a medium shot.

the camera, it's time for variations. Next, try photographs, still with the frontal face, but with the eyes looking off camera, at another person or object, or even glancing down in a pensive moment. (See photo 2-7 of Skylah.) You may very well have tried these angles in your early attempts at close ups, but if you haven't, now is the time to do so. Next, watch for ways to take a close-up of your child's profile.

Sometimes the opportunity to get a nice profile close up will present itself when a pensive child gazes out a window. Again, the eyes are what you want sharp. Sometimes if you are working in very low light, only one eye in a profile will be sharp. In chapter 11 you'll learn more about the effect of light on focus.

Is It Easy to Shoot Close-ups?

It takes some practice and perseverance to work close and still catch both the sharpness and the expression you need for an extraordinary photograph. Don't be disappointed if, at first,

the mercurial movements of your baby make it difficult to catch the moment and the sharpness you want. It takes patience, effort, and lots of shots. But great photos will happen if you stick with it. A lot depends on the age and personality of the child. Babies with a calm, sanguine disposition will stay quiet, looking at you long enough to give ample time to focus and shoot. Other babies are quicksilver fast, flicking their eyes in many directions or darting about the room, allowing barely a split second for you to focus and press the shutter.

Shoot a Lot!

Don't be discouraged if you have many out-of-focus shots at first. Just understand that you may have to take double or triple the number of photos you are used to taking. And have the patience to wait for an interesting expression. There are times when a blurry photo has artistic value, but at the outset, try for sharp photos. You can break the rules later. Or simply recognize when a mistake is actually a success.

I suggest that a subtheme of this book is that you can never take too many pictures—actually, all of chapter 8 is devoted to this premise. Unless you are unusual, you probably

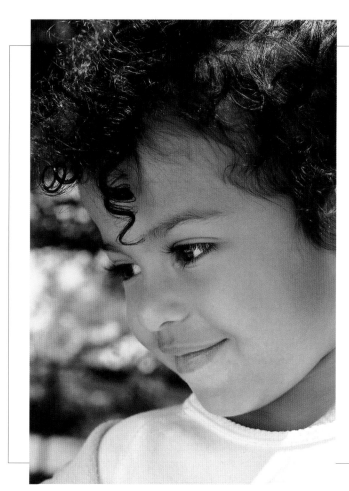

[2-7] The three-quarter-angle photo of Skylah is a good example of another approach to close-ups beyond the standard frontal-face framing.

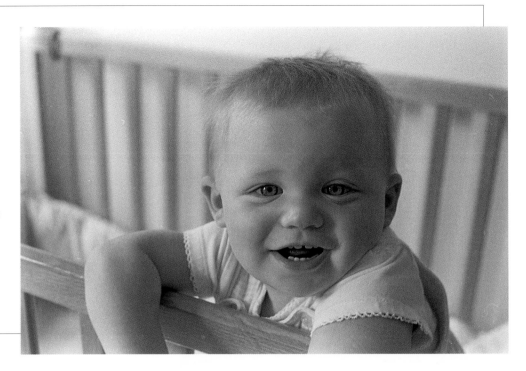

[2-8] Cassidy woke from her nap in a cheerful mood and ready to chat. There was good light from the nearby window where we had moved the crib, so I made the most of her being contained in one spot, where focusing was reasonably easy. Working fast, I caught a number of charming expressions before she lobbied to be taken out to play with her siblings.

need to take many more pictures than you think necessary. In almost every chapter you'll see why more is better in order to get a few really great photos. At this moment we are looking at shooting volume as a solution for getting good, sharp close-up photos of active babies.

Getting Sharp Close-Ups

A partial solution to the difficulty of getting sharp focus on a moving child is to find a satisfactory method of containment. Photographing close-up faces is easier if a baby is young enough to be happily confined, which is usually between six and nine months, up to the age when they learn to crawl. Before that age, you have opportunities when they are in a high chair, crib, playpen, or backpack to concentrate on close-ups of their faces. Simply move their chair or playpen to a location where you have good light, as we did in photo 2-8. This confinement can minimize the movement that makes focusing so frustrating, because it keeps them within arm's length.

The most difficult time for taking close-ups of babies is when they have learned the power of locomotion—first crawling, then walking. They are thrilled with the process and, until they collapse at naptime, seem to want to scoot everywhere they can. This makes your job more difficult. Even more patience is needed to wait until they come to rest and pause to look at you for encouragement, or with an expression of delight at their newfound power. Capturing that look of triumphant glee will be worth the wait.

Children are unpredictable. If your baby is full of energy and doesn't want to sit still, you may have to suspend your close-up photos in favor of another approach. You might go with action photos, to try to capture the movement. If you can't cajole the child into the type

of situation you want to photograph, then work with whatever she is in the mood to do. Give in to the inevitable. Don't force the issue if close-ups aren't forthcoming. You can hone your skills to where it's easy to shift from one style of photography to another—that is, to take the photo that's available.

Distractions

There are times to provide distractions to get a baby's attention and try for a good expression. Squeaky toys, jingling keys, or waving hands are proven to get quick, predictable smiles in a short period of time, which is why this technique is used in the portrait-while-you-wait photo studios. These photo outlets provide a very good and inexpensive service to people who want satisfactory pictures but aren't interested, or able, to get such results themselves. If you are reading this book, you've already decided that you want more than that for your child.

I find it's best not to harass the child with exaggerated commands to look this way or that—or to allow hysterical efforts from other family members dangling toys to raise the excitement in the room. The end result could be confusion for the baby, simply frazzling his or her nerves. At first, work just with two of you, you and the baby. Or possibly have one other person standing slightly behind you. Minimize the instructions you give the baby. Talk gently and see what happens. I find that an older sibling can be a great help keeping a baby's interest without creating havoc.

The use of distractions to spark an expression should be introduced slowly and used sparingly. You'll see that too much commotion will simply dull the child's interest as he or she gets used to the cacophony you and other family members have created. Glazed eyes are not what you want in the photo.

Realize also that dangling toys in front of a child might get one or two delighted expressions but could also backfire into irritation if you torment her by holding the toys just outside her grasp. Be prepared to let the baby play with a toy if you proffer it. Know also that it will almost surely end up in her mouth, putting a temporary halt to the kind of photography you want. A few photos of drooling and chewing on a favorite toy might appeal to you, as snapshots do, but it's not the primary portrait. (However, go ahead and take a snapshot if the portrait is not working.)

Not by Face Alone Do We Know Ye

Go beyond photographs of your child's face. Look for other endearing details that symbolize your baby or child. Try close-up photographs of body parts such as a tiny foot peeping out of a blanket, little fingers curled in sleep, or hands clutching a favorite toy. Older children aren't as easy to approach in this way, but there are moments when they are concentrating on an activity, which can provide evocative details to photograph. Picture a school age child's paint-spattered hand holding a brush, or stringing beads, or attaching a hook to a fishing line.

Finally, the value of close-up photography is that with closeness comes a strong emotional tie with the child, and photographs that evoke all those warm feelings.

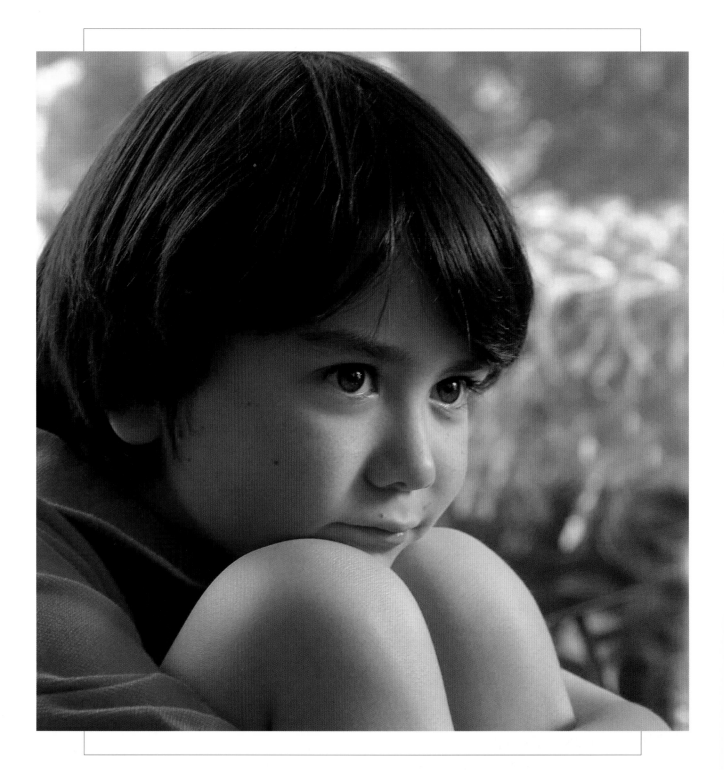

Variety in Portrait Styles

Armed with the tip "closer is better," hopefully you've followed the advice in the last chapter and gotten some delicious close-ups. That makes it time to turn to something different, and use your creativity and imagination in a new way. You'll not only take a different approach to face shots, but will add variety to your repertoire of photography by using other distances and other angles in a variety of positions and locations. Move back and look at your child from another viewpoint.

Framing Faces

You may have concentrated on straight, frontal face shots when doing close-ups. Now try to loosen up a bit and change your positioning. Frontal face shots evenly balanced in the frame can have impact, but they can also be boring if done too often. So I try to vary the framing. I've been known to overdo it and cut off an ear, or do something equally awkward. It's better to push the limits than to stay too predictable in your composition. Sometimes, as in the photo of Petey (3-3), it's almost too much. He leaned toward me for just a second, so I shot instead of waiting to frame and risk losing the expression. Does it work? That's debatable. Could cropping improve it? Maybe.

Experiment and decide on your own style preference in framing face shots. Though photo 3-1 is much wider than a standard face shot, it shows how far you can push off-center framing and still have a strong portrait. This is extreme framing that works well.

Move Farther Away

Now that you have succeeded at close-up photos, try taking face shots from a medium distance. Head-and-shoulder photographs are taken from a medium distance, and often done

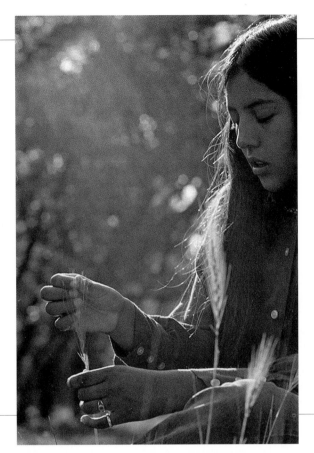

[3-1] This photo of Mary concentrating on a stalk of wild grass is an example of intentional off-center framing—a photo pushed to its limits. But the strength of Mary's eyes looking at the grass holds it together, because the viewer's eyes go down to the hands, then back to the top again, resting on the lovely face of a girl absorbed in the moment.

with a 90mm lens, which is considered the photographer's classic portrait lens. These are considered the archetypal portrait and can make perfectly fine pictures. They are safe and, not unlike the school portraits you see every year, provide a record of the child. The danger is that these photos will become for you merely standard predictable photos. To avoid the ordinary, consider varying your perspective. If you have been shooting mostly horizontal photos, try verticals; and for a fresher look mix in some views of the face turned at an angle slightly away from the camera.

Busy Kids

Another way to give extra interest to photos that might otherwise be simply standard shots is to use the medium distance for photos of a child occupied with an activity. This could mean photographing an infant on a blanket on the floor playing with a rattle, a toddler peering at the viewer, or a preschooler reading or playing with blocks. Any time children are occupied, they may suddenly give a movement, a quick gesture that is quintessentially *them*. You can even get interesting moments when you catch them at a meal.

▶ *Vary angles.* Include some profiles. Though a dramatic face-on photo of your child has impact, it's good to remember that a child is three dimensional. Look at all the

[3-2] Babies and children who are occupied in activities they enjoy can provide lovely photographic moments.

other sides. Profiles can provide amazing and satisfying photos that capture something you see every day but maybe haven't thought to include in a photograph. When you see your child in profile, take the picture. Resist the impulse to say "Look over here."

▶ *Vary the width.* There are times to take a photo with a wide angle of view. But it's important to do it intentionally rather than as a mistake. If the child is merely a small element against an uninteresting background, then the wide shot is wasted. An intentional and successful wide shot will include a great deal of the background in a way that suggests something special about the child's world. It includes details that add to your understanding of the child's life.

▶ *Vary locations.* Let the environment of a child's life suggest unusual and interesting settings for your wide shots. Look at the variety of locations in the photo grouping 3-6 to see that virtually any place can yield a spontaneous moment. Those photos show cozy corners and favorite outdoor haunts of your child, as well as shadowy environments. Silhouettes are extremely effective. (Be warned about one pitfall when shooting silhouettes: the automatic exposure setting on your camera can make the subject too light. It can't know that your goal in this case is a dark figure. You'll

[3-3] The photo of Petey peeking in from the left side of the frame is worth keeping just for his sweet expression, but I wish I had been quick enough to get the spontaneous look with a less-extreme framing.

find more on metering in chapter 11.) The familiar shape of your child will sing out to you even in a shadowy hallway. Not every photo has to be brightly lighted, with clear details. A silhouette of your child in a pleasing or familiar environment can make an evocative photograph.

Full Figure

When you show the full body of your child, try to have it be in a natural situation, one the child has chosen, rather than where you might pose them, ramrod straight as statues. Your memories of your child will be enhanced by having photographs that show his or her full figure.

The shapes of children's bodies are almost as individual as their faces. The way they move, pause, and turn are all imbued with subtle gestures that you recognize as special to your child. Capture that. And do it at various ages as they grow.

[3-4] Vary your composition—try vertical photos. Choose what pleases you. I left Abby's straggling hair as is. Your children aren't perfectly manicured when you live with them, so record them in photographs with their natural disarray.

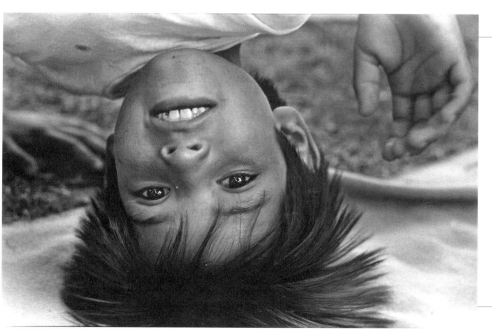

[3-5] Mickey hanging upside down from a jungle gym is the unusual angle and spontaneous moment you'll want to capture.

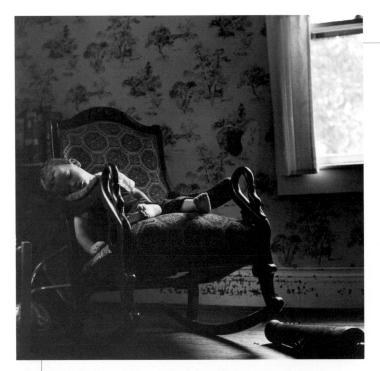

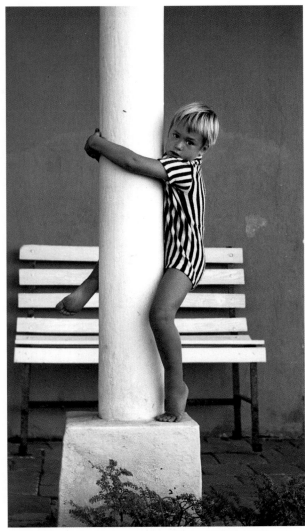

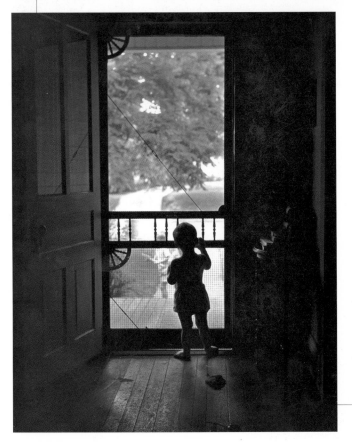

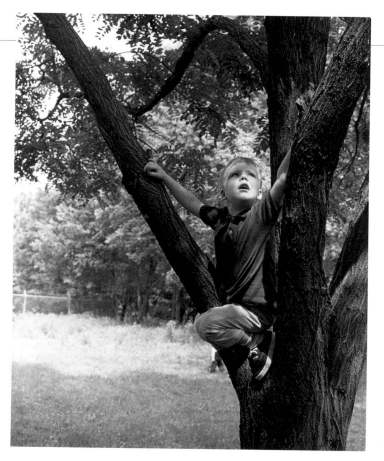

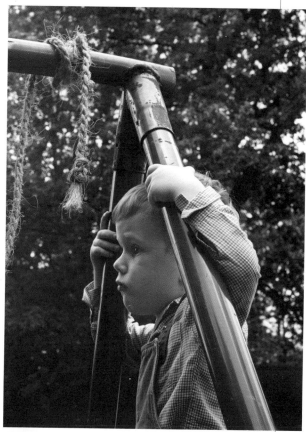

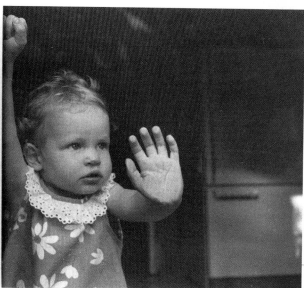

[3-6] This spread shows a range of angles and scenes to suggest ways you can bring variety of style into your own portraits.

[3-7] This sweet, quiet moment of Erin in the grass while she paused to look for more flowers doesn't show all of her face, but it is just as evocative to her parents. Then she turned, and grabbing a branch, flooded us with the light of her smile.

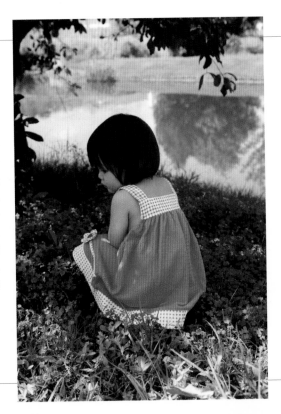

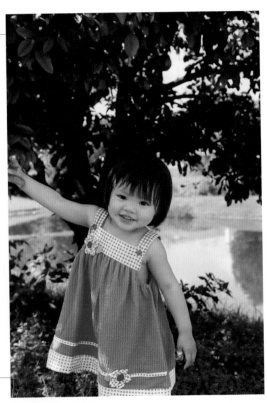

A

[3-8] Getting any photos of a teenage boy is a challenge, especially unusual angles or moods. Grant was cooperative, but it took some time talking together to get the natural look in photo A. Catching the pensive profile (B) took even more patience.

B

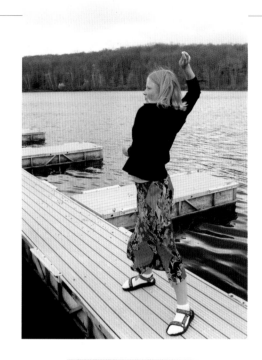

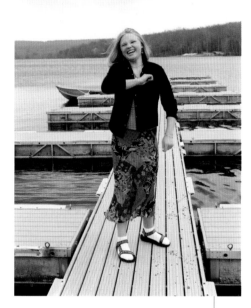

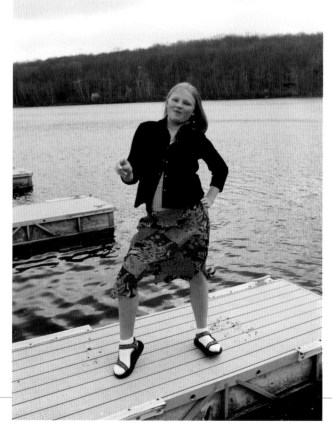

[3-9] These photos of Elya prancing and playing are not fine portraits of her, but they catch her energy and personality.

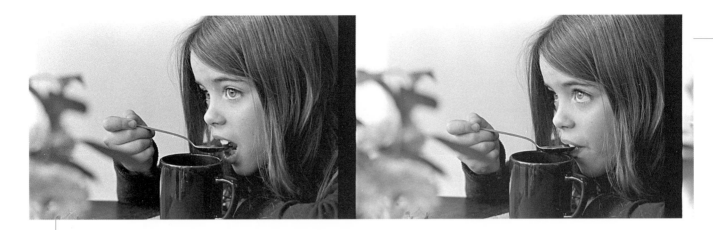

Achieving These Moments

One way to be ready for a nice moment is to watch, wait, move, follow, follow, follow—all with the camera to your eye, sometimes taking pictures, sometimes just looking. (This advice will come up again in chapter 8.)

But sometimes you don't have a lot of opportunity for pictures, so you grab what you can, and wherever. Recently, on our way to a wedding in rural New Jersey, a friend, her daughter, and I realized we would be early for the ceremony. To break the drive, we stopped by a lake to allow twelve-year-old Elya to let off some steam. Not mindful of her wedding finery, Elya romped on a dock, pitched pebbles, and got out the kinks from a long ride. Her mother loved the pictures. (See 3-9.)

Are these portraits? Who knows? Maybe they are just delightful snaps. All the same, for her mother they catch Elya's exuberance and that brief moment at the age of twelve when colt and tomboy mix with rare charm.

As with the photos in 3-9, however eccentric a location may seem, you may find these are the only moments you have for photography. The photos in 3-10 of Cassie eating lunch are an unconventional situation that did yield one interesting moment. The first three frames are odd, right on the edge of bizarre. Who'd want to photograph a kid slurping her soup? Well, since I had only a brief visit with the family on a dreary November weekend, my chances for a photograph as a gift for her parents were few. So, my only choice was to work at lunch. My approach was to start taking photos as she was eating—and then to watch, wait, and finally catch her quick look toward the camera.

Achieving a variety of style in your children's portraits means letting yourself go in terms of the angles, the locations and the lighting you use. Mix in an exuberant imagination and you'll find the reality of your child's world.

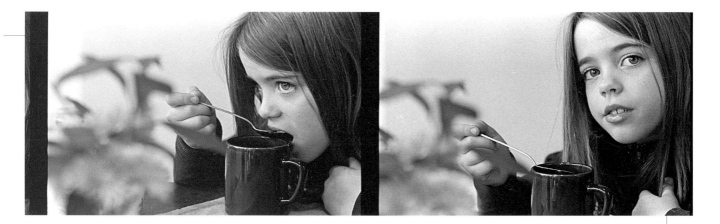

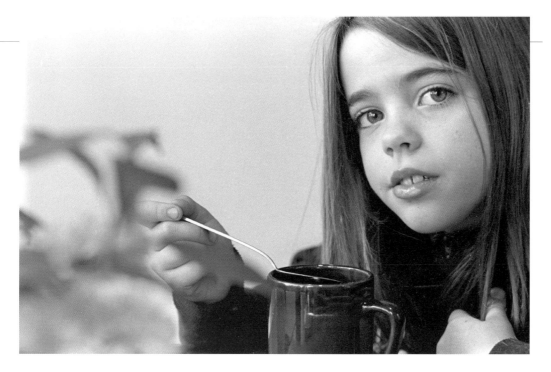

[3-10] The direct, intense gaze from the self-possessed, eight-year-old Cassie when she looked up from eating her soup was worth taking all the previous, slightly peculiar shots you see on the contact sheet.

CHAPTER 4

Don't Smile: Capturing All Moods

The title for this chapter, "Don't Smile," may not seem broad enough to encompass all the points to be made about varying moods. And if you consider the phrase *don't smile*, it might seem puzzling as guidance for child photography, going against the time-honored belief that happiness, exhibited by a smile, is the ideal expression to record. But it's not. Smiling expresses merely one aspect of our humanness. Smiles, authentic smiles, are delightful. But you need to go beyond them to reach the true nature of your child.

Children are complex beings with many-faceted personalities. It's the emerging personality, captured on film, that you will treasure in later years. I'd venture to say that there are no moods unworthy of photographs. But the reason I start with the premise of "don't smile" is that literally, if you ask for a smile, the result may be a grimace, simply a baring of teeth without any smile in the eyes. Look at the photos in 4-3.

The Value of Other Moods

Another reason I named this chapter "Don't Smile" is so you will start to think beyond smiling. Realize the delight of capturing the many moods of your child. Think about how you see her. Remember how you are touched by the mercurial changes you see in the eyes, the mouth, the scrunching of the forehead when she is thinking, the quizzical look when concentrating, the lowered lashes—even the crying or pouting. You will retain so many more moments of childhood if you photograph a full range of emotions.

Don't be afraid of serious or pensive moments. (Though it is not the purpose of this chapter to have you in tears by the end.) You'll find that quiet or serious moments can be poignant without being depressing.

Techniques to Get Smiles

If you have enough pensive photos and really want a smile, here are some tricks to get that smile and other good expressions along the way. In order to end with a smile, like many things in life, if you don't force it, you may get it.

Talking

The path to a genuine smile is often through other means such as conversation. Try asking children to tell stories from school, the names of special dolls, or the plot of a favorite television show. If you respond with interest or amusement they may echo your expression. If you can get a child talking to you, and keep photographing, you will get some interesting expressions, valuable in themselves, that may also result in a smile. And the effort will have been worth it for the other looks you'll have captured.

Surprise

Another method for getting smiles is the use of surprise. When working with babies any variation of a classic and time-honored game such as peek-a-boo will bring a smile. Another surprise routine that I've used with success is the pull-the-hair-of-the-photographer ploy. It's slapstick enough to get a laugh from the toddler through preschool child. But the sudden delight of the younger children is usually infectious enough to get a laugh from anyone else—adult or older child—in the photo. Here's the way it works. You enlist the aid of a sibling or other relative. Secretly you tell this person to pull your hair while you are taking photos. Then when you look around in puzzlement or annoyance to find the culprit, your hair-puller feigns innocence. It can be repeated several times to the great delight of the audience. I've even been known to ask a stranger to help. For the laughs in the family group photo below, I actually got a passerby to pull my hair. My goal was to bring the grumpy toddler out of his mood. It worked.

[4-1]

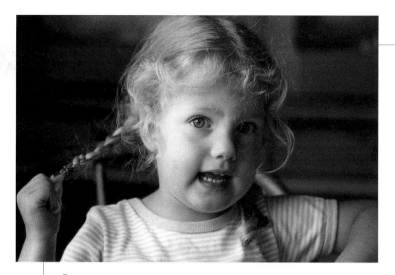

A

B

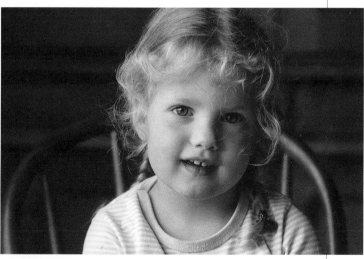

C

[4-2] If you want a smile—and they are captivating—wait for it. You won't necessarily get one by asking. Emma pulling her braid while chatting (A) is quintessential Emma and just as valuable as all the smiling photos we have of her. Then, she relaxed into the story she was telling (B) and listened to our answer with a gentle smile. Conversation will yield odd but endearing expressions. I particularly remember that little Gloria (C) was saying the baby equivalent of "Harumph!" or "So what do you want from me?" and since it was a typical gesture, it was as beloved by her parents as an expression of her personality as any smiling photo I gave them.

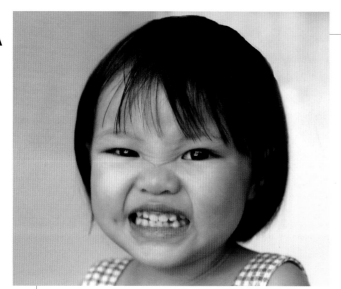

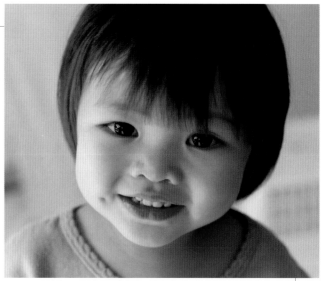

[4-3] When you do try for a smile, wait until you get a genuine one. Here, when asked to smile, Erin just showed her teeth (A). Then later during a conversation about her favorite toy, she offered a sweet, dimpled smile that glows in her eyes (B). But it wouldn't have appeared on request. Next we see Alex, photographed by his mother (C). He was responding to her request to "say cheese." It's fun to have this picture, but it doesn't show his lovely eyes and candid expression as in the spontaneous, less-posed version (D).

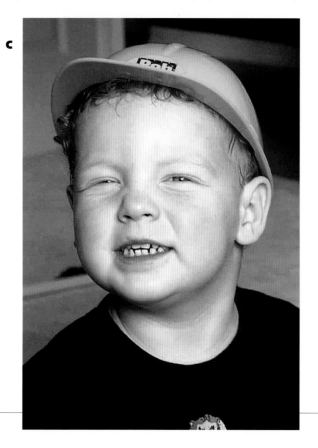

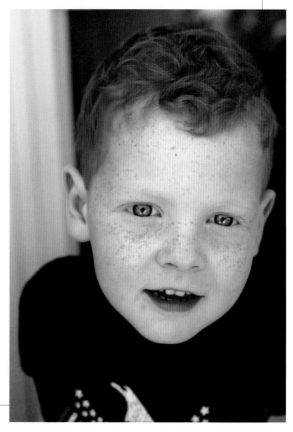

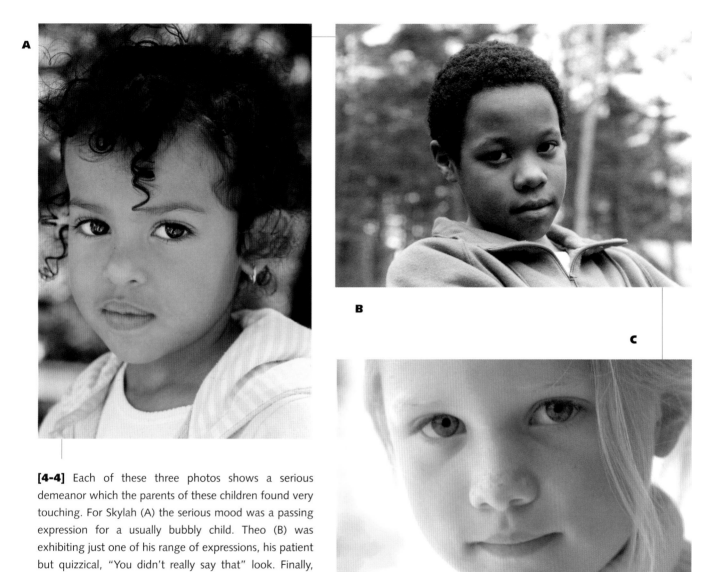

[4-4] Each of these three photos shows a serious demeanor which the parents of these children found very touching. For Skylah (A) the serious mood was a passing expression for a usually bubbly child. Theo (B) was exhibiting just one of his range of expressions, his patient but quizzical, "You didn't really say that" look. Finally, Carly (C) shows her self-possession through her level gaze in this close-up, intimate portrait.

Range of Emotion

The groupings of photos in 4-5 on the next page give a full range of moods, each one of which was highly valued by the parents of those children. One parent commented "I always see that expression but never thought to photograph it. How wonderful to have it on film."

Knowing who they are and remembering who they were in all their moods is the real payoff for the extra effort you are putting into your photography.

41

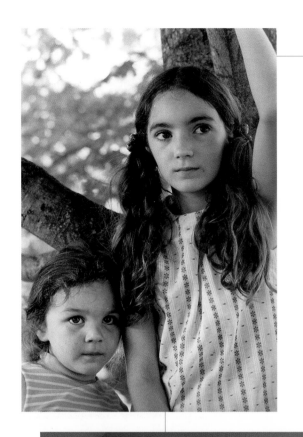

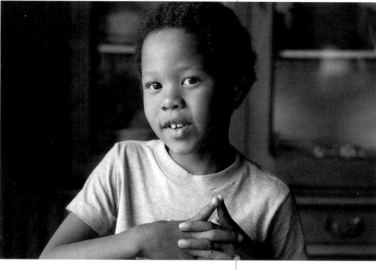

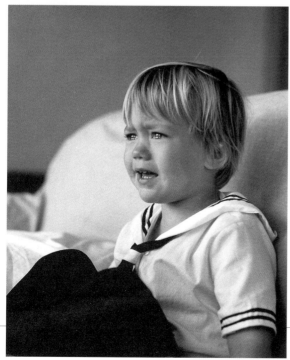

[4-5] All of the moods and emotions in the photos of these children touch their parents' hearts. Don't shy away from serious or unusual expressions.

43

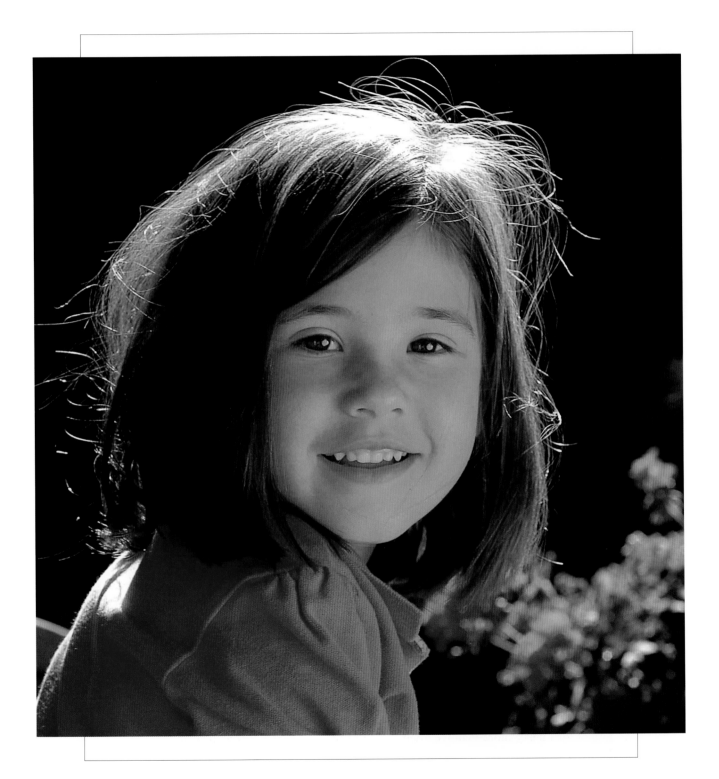

Lighting: Natural or Artificial

Light is what creates all photographs. Light passes through a lens and hits chemical layers on the film surface, or is recorded on the photo card in a digital camera. Light is the beginning and the end of photography.

The type of light you choose, or the light you create, will affect both the aesthetic and technical success of your photographs. What you can do with light is determined, to some extent, by the capabilities of your camera and lenses. Regardless of any equipment limitations, the more you understand light, the more it will serve you in creating better portraits. How light affects technical aspects of photography, such as sharpness and stopping action, will be covered in chapters 7 and 11.

Becoming aware of the *quality* of light is the first step in mastering lighting. Developing an increased sensitivity to light can be a thrilling and enriching experience. Many photographers were probably first seduced into the medium by seeing the magic of light falling on the world around them. You have the added joy of seeing light as it falls on your children as you photograph them. The right light simply enhances what you already know and cherish about your child and allows those qualities to shine through in photographs.

Sources of Light

We often take light for granted, merely being aware that there is a lot or a little of it—whether it's the cheerful light of a bright, cloudless day, the moody light from a heavy overcast sky, or the stirring, dramatic light of a coming storm. In human terms, light affects our spirits and sense of well being more than we often acknowledge. It is also a central element in a beautiful portrait.

Types of Light

To improve your photographs, and your enjoyment of them, take a new look at light even before picking up the camera again. Note the subtleties in the quality of light—how it falls on the tree leaves, highlights the architectural detail on buildings, touches the hair of a child, or adds a fiery glow to a field of flowers. Notice too, how the effect of light changes according to the time of day.

Then go beyond these obvious delights to observe how light falls on faces in many different settings: by a window, on a porch, in a restaurant, in the backseat of a car. The glow of light can transform even the most mundane locations and, of course, the child, your dear subject, in that location. Analyze the light you see in these various spots and decide if it enhances or obscures the face, the expressions, and the mood of a person.

Eyes

Again, keep in mind that "Eyes are the windows to the soul." In a photographic portrait, the eyes are the windows to the essence of your child. The reason for harping on this is to emphasize the importance of using light that enhances rather than obscures the eyes. For good pictures, the key is to choose the type of light that appeals to you, that your equipment can handle, and that shows your child to best advantage. The sample photographs in this chapter will help you understand what results you're likely to get from each type of light. If you see what works and what doesn't work in these sample photos, you may be saved from those mistakes in your own precious photos.

Definitions

Photographers use many terms to describe light, some of which overlap in meaning. Also, in any given location there can be more than one type of light. The mix of light will affect the look and sometimes the color tone of your pictures. For those intrigued by the variety of types of light, as defined by photographers, you can do more reading in some of the photography books listed on the last page of this book. For those who want to move on, just be aware that the basic and obvious distinction is between natural light and artificial light.

Natural light is any light originating from the sun (this includes light reflected from the moon). It can include bright sunlight, open shade, cloudy daylight, or the dim light of a drizzly day. You'll find natural light outdoors in the sun, under the shade of a tree, or indoors near a window or doorway.

Artificial light is created by humans and powered by batteries or AC current. It includes the flash on your camera, a professional set of strobe lights, "hot lights" such as photographic flood lamps, incandescent light (household bulbs), and fluorescent light. The most common artificial light used by the amateur photographer is on-camera flash, which is simply a small strobe that is either built in or attached to the camera. These two basic light sources include many gradations. We'll touch upon the pros and cons of some of the more common types of lighting. It's helpful to get a feeling for types of light and to understand the advantages and disadvantages of each. Sample photographs will illustrate the differences. Then experimentation on your part will finish the job.

Advantages of Natural Light

One advantage to natural light is that you see exactly what you are getting—you see what the camera sees. Also, if you choose the right location in which to shoot (open shade, for example), natural light is often a more pleasing light than the various types of artificial light. The exception is if you are a professional or advanced amateur skilled at using strobe light—then artificial light can provide a stunning result. But for most parents, learning how to make the most of natural light is the best beginning. And in many ways it remains the loveliest light there is.

Disadvantages of Natural Light

The disadvantage is that there are certain times of day, weather, and locations where there isn't enough natural light to get a good, sharp photograph. At those times, you can use a flash and take snapshots, or just wait for another time. And, as you'll see later, some natural sunlight is too harsh for good portraits.

Advantages of Artificial Light

The advantage to flash is that you can get pictures in murky light or at night, when no natural light is available. It's certainly the lighting of choice when something is better than nothing. (As you will see later, it can also be useful as "fill flash" to avoid deep shadows from harsh sun.) I encourage the use of flash for snapshots. As discussed in chapter 1, snapshots must not be abandoned simply because you are taking another level of portrait. Just understand the ways flash may limit the quality of your results.

The other artificial light, a photographic flood lamp, or hot light, is seldom used or recommended these days for portraits. It does provide the advantage of seeing what you are getting, but the amount of heat it produces for the amount of lighting power it provides puts it low on my list of lighting choices. It's the type of light probably used by your grandparents to take the group shots you've seen in the family album. But for your work in child portraiture it isn't necessary, as there are plenty of other types of lighting.

Disadvantages of Artificial Light

A characteristic of light from a flash is that the light lasts for a fraction of a second, illuminates the subject, and is gone. The speed of the flash contributes to its main disadvantage—you don't see what you are going to get. You don't know if there will be a distracting reflection in the mirror behind the child, red eye, or an inky black background behind your subject. Of course, with your digital camera you *will* be able to see anything that goes wrong. However until you've had some practice, it's difficult to control the quality of light with an on-camera flash. In chapter 11 you'll find information about fill flash, on and off camera, and the time-delay feature to reduce red-eye.

Good Light/Bad Light

Though it sounds judgmental, photographers tend to speak of good light and bad light. Depending on the type of photography the same light might be good or bad. For example,

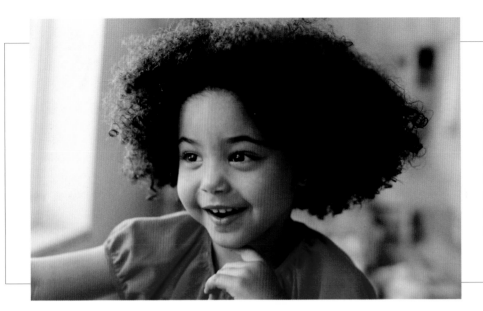

[5-1] Maya is seen in the gentle natural light from a window. The subtle shadows give her face a pleasing, sculpted, three-dimensional quality. Also, the light isn't forcing her face into a grimace; her eyes can stay open and clear as she smiles at the progress of the letter carrier up the street.

[5-2] The contrast between natural light and flash are clearly seen in this pair of photos of baby Darcy. I prefer the quality of the natural light (A) to the flash version of the photo (B). To me, flash destroys the magical glow of the window light. Also, because of the difference between the strong power of the flash and the relatively gentler exterior light, the outside appears as dark as night in the flash photo. However, in some cases the flash will heighten the color and brightness of a photo. If that's your goal, then flash may appeal to you. Try photos both ways.

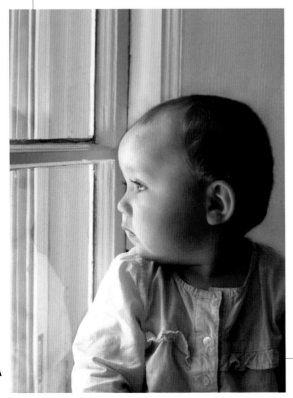

A

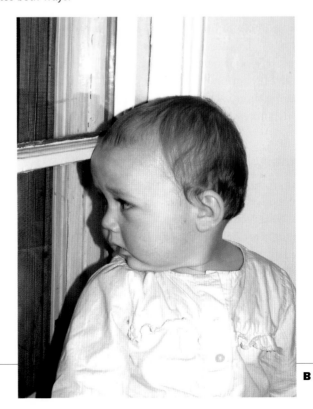

B

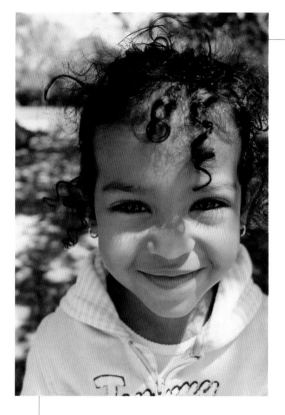

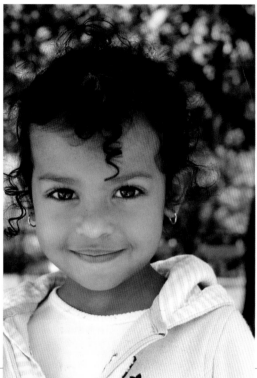

[5-3] Skylah is seen first in bright sun, then in open shade. In this case we solved the squinty-eye difficulty from the splotchy sunlight by simply moving her into an area of open shade. (Note: You may think you've found a shady area with good light, but beware of wind moving the branches providing the shade, as this can ruin the nice open shade you've found by letting in splashes of sun.)

[5-4] Sunlight can be very pleasing in an outdoor action scene if you aren't trying for facial expression. This beach scene benefits from the bright colors due to the sun being behind the camera. The slight blotching on the cousins' faces is irrelevant in this setting, since these aren't close-up photos.

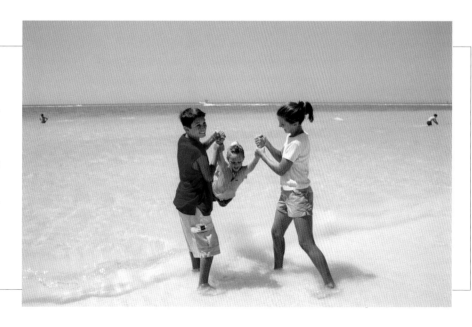

what is good light for landscape or architecture may not be ideal for portraits—as you'll see below when we talk about sunlight.

Good light is any light that allows you to see the detail in the eyes and to see expression clearly. It gives a gentle tone to the face. Open shade tops my list of types of good light.

Bad light is any light that obscures detail or forces the subject to squint or frown. Harsh midday sun is perhaps the most detrimental light for portraits.

Open Shade

The easiest way to get pleasing natural light for portraits is to find open shade. Open shade usually provides the right amount of light—enough brightness to get sharp pictures—but doesn't cause shadows or elicit awful scrunching and facial grimaces from young kids. As you'll learn later in this chapter, you can find open shade or create your own.

Sunshine: Friend or Enemy?

A sunny day can be great for pictures, because you have bright light and lots of it. Controlling the sunlight is critical. Early photo pamphlets (and current disposable camera guides) suggest that you keep the sun behind you, falling onto your subject. That is a safe approach and prevents the problems caused by allowing the sun to shine directly onto your lens. Sun shining directly on the subject brings out bright colors and creates an intense blue in the sky, which can be suitable for landscapes and architecture. The problem with photographing people with sunshine directly on them is that faces are often distorted when the subject squints against the direct sun. Sun can also cause harsh shadows on the face so that details in the eyes are lost. However, as you see in the beach photo 5-4, when you photograph your kids in a wide shot where they are a part of beautiful natural environment, then bright sunshine can be fine.

Backlighting: A Solution to Direct Sunlight

Depending on the angle of the sun, sometimes the cure to when your child is squinting into the sun is putting the sun behind your subject instead of behind you. The subject will have less trouble keeping the eyes open, and usually there will be a nice halo of light coming from behind. This approach is called "backlighting." Backlighting requires certain sophistication in understanding light, because while the halo effect of backlighting is lovely, the result may be that the face is a bit too dark. Creating the backlight is just the first step in the process. Later in this chapter, we'll touch on the cures for adding light on the face, such as using a reflector or fill flash. Time of day is a factor—midday sun can make even backlighting difficult for portraits—as you can see in photos 5-5. Another caveat when using backlighting is to make sure that the sun isn't in your lens. It takes a bit more planning, but backlighting can be a real asset in creating elegant light for your portraits.

Avoiding Glare

Photographers sometimes use the terms glare and flare interchangeably. *Glare* is a bright, intense, dazzling light which, when it hits the lens, causes a *flare* effect. It's unwanted light

A

B

[5-5] Alex, Sam, and Leah were facing the sun (A) and then turned around with their backs to it (B). We used a reflector to improve the exposure on their faces. There is a pleasing halo from the backlighting. Though it's much better than when they faced the sun, it's still not very successful. They continue to squint slightly. Why? We were shooting at noon, and even with them facing away from the sun, the light was flooding in everywhere (note the glare on the grass behind them). Solution? Try to photograph in the mornings or late afternoons if you can. Midday is tough on a sunny day.

reaching the image. The main issue here is to avoid having the direct sun hit your lens. You'll know if the sun is in your lens because of the diffusion effect you'll see in the viewfinder. The diffusion may appear as a soft blurry look, or sometimes as a rainbow streak of light across the picture. Occasionally, glare can add a creative look to your photo, but mostly it merely obscures the face of your subject. It takes some experience for you to identify and avoid glare. To train your eye, try an experiment—but don't use your child, since you don't want to lose a lovely image. Try setting up a photo with an adult friend. Place her back to the sun, and while looking through the lens, move the lens very slightly toward the sun until you see the glare. Then hold your hand out above the lens (or to the side of the lens) to shade it until the glare disappears. You'll see the difference: When the sun is in the lens, the image will have slightly fuzzy edges and the color will be washed out. When your hand shades the lens and removes the glare, the subject is clearer and the colors brighter. Take the next step in the experiment by shooting some photos of your adult friend with and without the glare. Studying your test photos at leisure will increase your understanding of this lighting effect. Backlighting is a delicious effect and worth the trouble to master.

Avoiding the glare can be accomplished easily if you have a partner working with you. See photos in 5-6. That person can check glare for you by standing in front of the camera to see if she notices the sun hitting the lens. A friend can help further by holding a piece of cardboard just above the front of the lens, or to one side, to protect from the glare that will cause flare in the lens. Of course you must be careful not to show the edge of that cardboard in the frame of your photo. In a digital photo, glare can be minimized through manipulation in Photoshop® or a similar editing program, but results are best if you avoid glare at the outset.

51

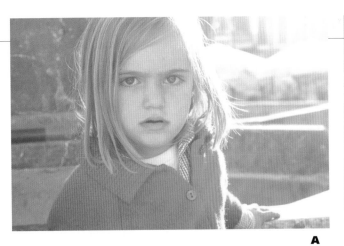 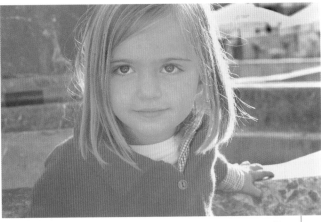

A **B**

[5-6] Glare occurs most often when the sun is at a low angle in the sky, either early morning or late day. These late afternoon photos of Gloria show glare caused by the sun on the lens (A), and then the absence of glare because the lens was shaded (B). Gloria's father helped me by holding a card above the lens to shade it from the direct sun. (Although it can be risky, low-angle sunlight still creates a wonderful light for photography—just be sure to protect your lens.)

[5-7] This doorway doesn't look like a glamorous spot for a photo and Abby sitting on a stool doesn't seem to promise a good photo. But I just moved in tight on her face and found a gentle light perfect for showing detail in the eyes. It's a quick convenient way to find nice light. For those who prefer black-and-white photography, you see the same lighting approach in chapter 6 (6-6A). The high contrast between the light on Sara's face and the stark background lends even more drama to an open shade portrait. Another method for creating good light is simply to move the furniture—as well as the child. Go back for a minute to chapter 2, photo 2-8. The baby Cassidy was taking a nap. When she woke, we simply pulled the crib closer to the window to increase the power of the light. The result was a lovely gentle light in which to work.

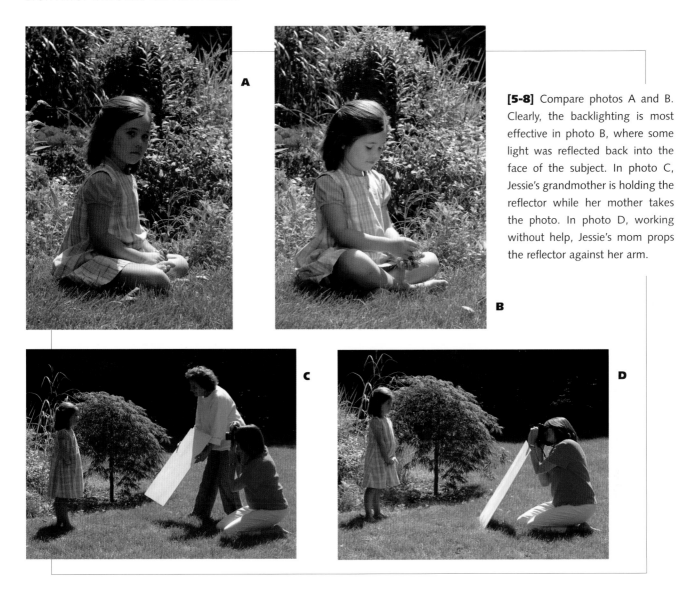

[5-8] Compare photos A and B. Clearly, the backlighting is most effective in photo B, where some light was reflected back into the face of the subject. In photo C, Jessie's grandmother is holding the reflector while her mother takes the photo. In photo D, working without help, Jessie's mom props the reflector against her arm.

Reflectors

When shooting with backlighting, the next element to check is whether there is enough light on the face. The lovely halo backlight is the first stage. Now you must judge if the face can be seen clearly. Generally the face will be too dark, in too much shadow, if the sun is behind your subject.

At this stage, do some research by checking photos in magazines. Did you ever notice that in magazine ads, the people are often happily strolling toward the camera with a glow of light behind them—but somehow there is still enough light from the front so that you can see the details in their faces? This is usually accomplished by having a reflector in front of the subject to "bounce" a softer light back onto them. What the reflector is doing is

53

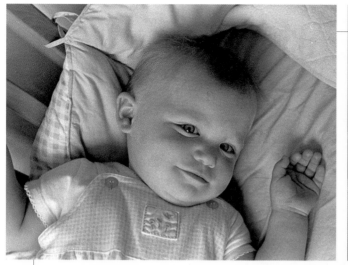

[5-9] Good light is available in many locations (a crib, restaurant, or balcony) that might not seem, at first glance, suitable for portraits. What these photos have in common is a gentle light on the children that allows us to see their expressions clearly. Wherever the light is good, the location is good—or you can make it so.

catching the sunlight that is heading toward the camera and bouncing it back onto the front of the subject. This provides light from the back and front simultaneously.

Reflectors can be white cardboard (or foam-core board) available at any art supply or stationary store. Also, you can buy professional reflectors at a camera dealer or online photo supplier. These are usually white on one side and silver or gold on the reverse to give an even brighter reflection. The silver or gold side is usually too bright for children—and defeats the purpose by causing the same eye scrunching that the sun brings about. Many of these professional reflectors are collapsible to a convenient size for storage or traveling.

Fill Flash

Actually, a similar effect can be achieved by using a flash outdoors instead of a reflector card to fill in the details; this is called "fill flash." It's even easier in some ways than using a

reflector to create your fill light as described above. Instead of having to perch a reflector in front of your subject, or have a helper hold one, the flash is right on your camera, ready to fill in the shadows. Many people swear by fill flash. I'm not crazy about it with kids. It does the job and is easy to use, but doesn't seem as pleasing as a soft, gentle, natural light. Fill flash removes shadows but it often removes the modeling of the face as well. It doesn't have the soul of natural light, if you'll forgive the sentimental aside.

Where to Find Good Light

You can either find or create good light. If you are inexperienced at taking portraits of your children, keep it simple. In your very earliest attempts at portraits, don't burden yourself with backlighting and other techniques that require some juggling. Find the easy, pleasing light of open shade. Later you can master the techniques for creating it.

I use the term "open shade" to define the light to look for when teaching yourself the new portraiture. It can be found virtually anywhere (except out in the sun!). Look for this light under the shade of a tree or awning, in a doorway, on a porch, or even indoors—by a window, just inside a garage, in a restaurant, or in a car. If the light is good, use it and don't worry about the clutter or possibly unattractive details found in odd locations such as cars or restaurants. If the light is good and you shoot fairly close-up, those details in the background become insignificant. And often they will be out of focus. In the next chapter, you'll learn how to build your own simple studio, which can guarantee good light and a nice background.

Creating Good Light

When you have difficulty finding open shade, or you want a quick solution for lighting without going far afield, try using your doorway or the edge of a porch. This works especially well on a bright day, when it's too sunny outdoors for portraits. There is the additional advantage that you are working close to the house and can keep your ear tuned to household events like phone calls (or when a sleeping baby awakes). Put a stool or chair at in the shade of the doorway—just behind where the sun would hit your subject. A nice bright light will fall on the subject and the background usually goes quite dark, which helps to highlight your child.

Create Open Shade in a Studio

You will find a section in chapter 6 on how to create your own studio background. In addition to solving the problem of having a clean background, the technique of building a simple studio in your garage or on your porch also lets you use open shade, which is simply wonderful, soft light. When you get to that section in chapter 6, take a look at the photos of Erin in her parents' studio to see the quality of light achieved.

Glasses

Should you take portraits with or without your child's eyeglasses? Do both. If you want a natural appearance, glasses may be part of who your child is and should stay on. But you might also want a direct look into the child's eyes—then shoot without glasses.

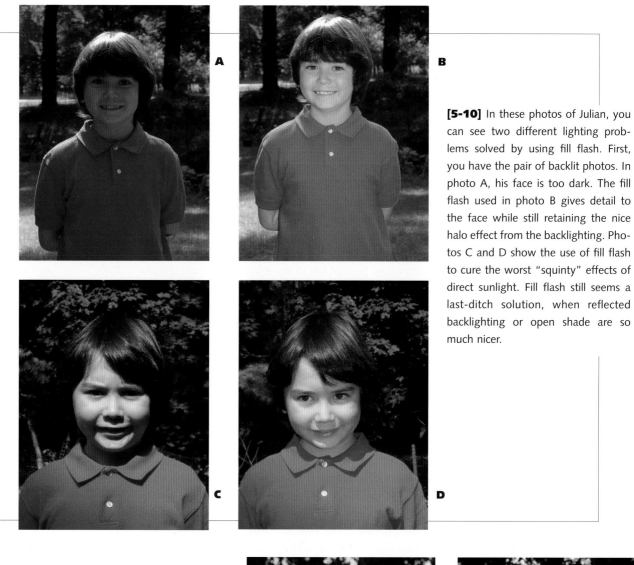

[5-10] In these photos of Julian, you can see two different lighting problems solved by using fill flash. First, you have the pair of backlit photos. In photo A, his face is too dark. The fill flash used in photo B gives detail to the face while still retaining the nice halo effect from the backlighting. Photos C and D show the use of fill flash to cure the worst "squinty" effects of direct sunlight. Fill flash still seems a last-ditch solution, when reflected backlighting or open shade are so much nicer.

[5-11] Have your child look in different directions until you find an angle where there are no reflections in her glasses.

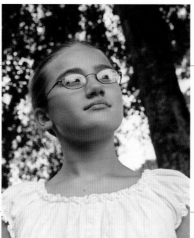
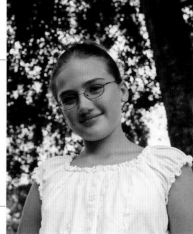

[5-12] These photos were taken moments apart in the same spot, an area of open shade. In photo A, the sun was out, though not directly on Marc's face. In photo B, the sun had gone behind a cloud. You see that in the first picture Marc's skin tone is healthy and pink, his sweater has a rosier beige look than in the second photo. There, without the sun, his skin and clothes have a cooler, almost washed-out tone. If you are working in digital, then color correction is not difficult. But in order to avoid extra work after the fact, be aware of the color influence of the sun when obscured by clouds. It's not necessarily bad to have this cool tone. Just understand why it happened and why some pictures have a different color-cast from others.

[5-13] Emily was sensitive to the bright light, squinting slightly even in this shady spot (A). Asking her to drop her chin fixed the problem and showed her lovely eyes (B).

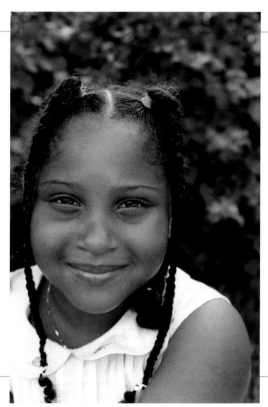 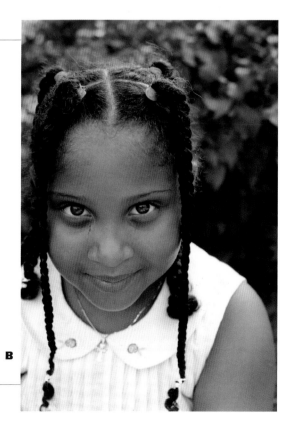

A B

When you take photographs of your child wearing glasses, do your best to avoid reflections on the lenses. (See 5-11.) When working in natural light, you can see and avoid the reflections. It's much more difficult to get rid of reflections from a flash. If you are shooting with a digital camera, you can have the child change head angles until you see in the LED viewer on the back of the camera that you've eliminated the reflection—but that pretty well stifles spontaneous expressions.

Color of Light

Color balance in film and digital photography is a science unto itself. But there are some basic precautions you can take to avoid situations that alter the skin tone of the children you photograph. Though shooting in open shade under a tree can provide beautiful light, there is a hidden danger. In some cases the leaves will cast a greenish light on the subject, which can create a sickly look. If overhanging leaves are reflecting a greenish light, you can move your child away from the spot, or brighten the skin tone by using a white card reflector, which will counter the green cast and give more natural skin tones.

It's not merely trees that influence your color balance. A basic point to remember is that the sun gives a warm tone (yellow) to light and absence of sun gives a cool tone (blue). This is true even in the shade. Here's what happens: if the sun is out and your subject is in open shade, the color balance of the light will still be warm, since the sun is out though not hitting your subject. If the sun goes under a cloud the light will become cool. Again, that will happen whether your subject was in the shade already or if he or she is in the open under a cloudy sky. Absence of sun gives a cool look to the photos. (See 5-12.)

Light Sensitivity

Some children are sensitive to light and have a difficult time not squinting, even in open shade. They can't help an involuntary reaction, which might be a slight frown or blink, as they strain to see in the bright light. Exhorting them to "open your eyes" probably won't help. Try to move them into a deeper shade where they face away from the light source (sun). Another trick is to ask them to drop their chins slightly. That seems to protect the eyes a bit, as you can see in the photos of Emily (5-13). This method isn't flattering to adults but on firm young faces, it's fine.

If your children are light sensitive, you may have better results if you take your photographs in the gentlest possible light, near a window, on a porch, away from the brightest light source. This holds true especially in areas like Florida, southern California, New Mexico, and Arizona. These places have a more intense light than northern areas. They are beautiful for photography but difficult for the light-sensitive child.

Adjusting Your Lighting for Skin Tone

Skin tones range from very pale to very dark and, of course, all the tones in between. This presents lighting challenges, especially on the extreme edges of the spectrum.

When photographing children with dark skin tones, watch for extreme contrasts that could fool your light meter. For example, if your dark-skinned child is wearing a white shirt

and standing in front of a pale background, the meter may measure the bright area, with the result that the exposure on your child's face will be too dark to see detail in the eyes. A solution is to put the child in clothing with color closer to the density of the skin tone, then place him in a background that is at least medium dark. This will give an exposure that's more consistent overall, preserving the authentic skin tonality of your child and revealing, rather than concealing, his expression. It also helps to use a reflector card to bounce light back into the face of your child, bringing out even more detail in the rich skin tones.

For the child with an extremely light complexion, the same contrast issue holds true. If you happen to have your pale child dressed in very dark clothes and near a dark background, such as dense foliage, the exposure balance may be thrown off. The meter may measure the dark area, with the result that the exposure on your child's face will be too light, washed-out looking, all detail bleached out. Especially when they are very young, pale children can have almost translucent skin. With them it's important to avoid bright sunlight for your photos. Try to work in open shade.

In both of these situations, you can override your automatic camera setting and adjust exposure for the skin tone of your child. But whenever you have extreme contrast something suffers, so it's worth adjusting the clothing, background color, and using reflectors for a more pleasing lighting overall.

Time of Day

Photographers like to say that, given their druthers, they would only shoot outdoors between 8 A.M. and 10 A.M., and then between 4 P.M. and 7 P.M. depending on seasonal variations of sunrise and sunset. These are the times when the light has a gentler low angle. But you can't always limit your photo shoots to this time of perfect light.

In midday, the light is often harsh, glaring down from overhead, creating awful dark areas under the subject's eyes and strong, unflattering shadows. The solution to this time of day is to run for cover to a shady porch, doorway, or tent, or to use the backlighting described earlier. Working in the shade of a tree can be a solution but with two caveats: avoid the splotchy light that may filter down and watch out for the green cast that the leaves may give to your subject.

You are now ready to see the world and your child in a different way. When you perceive the glow of light and master its use, you'll create beautiful portraits and have a heightened aesthetic appreciation of the world. Once you become sensitive to it, you may become addicted to searching out beautiful light for portraits.

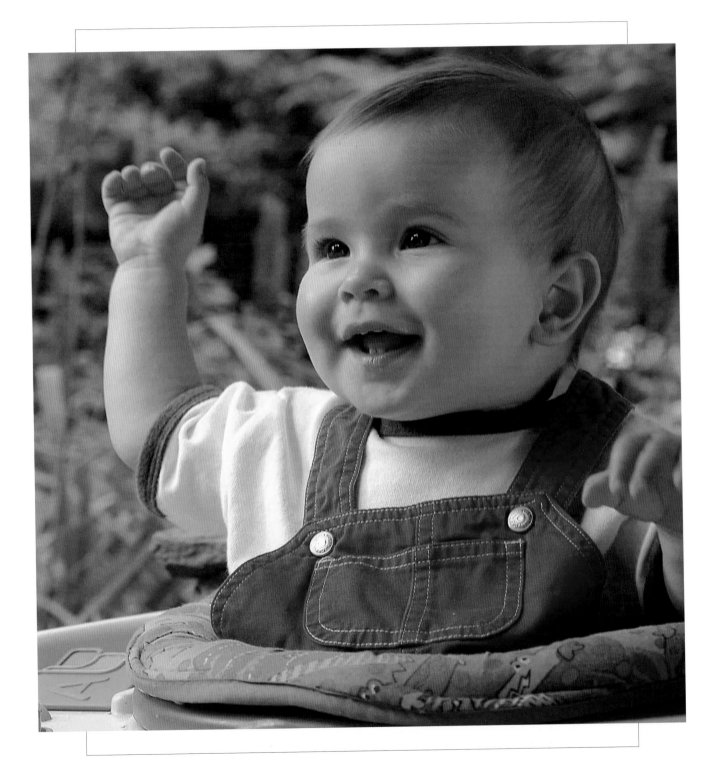

CHAPTER 6

Backgrounds: Where to Shoot

The background of a photograph may not seem as important as the lighting, the angle you choose, or the action you capture. But, as I hope the sample photos in this chapter will show you, the right background will immeasurably enhance your portraits of children.

The essential rule is to avoid any background that distracts from your subject. You might choose the framing of your portrait without noticing that behind your little one there is, in sharp and distracting focus, a tree limb, a light pole, or the sharp angle of a building. All of these details take the viewer's eye away from your child's face, the face you want to feature in your photograph.

Learning first to recognize, and then to avoid, those distractions is best done through trial and error. As a learning technique, go back through your photo albums and check the backgrounds of photos you've shot recently to see if they help or harm the photo. Then take a few test shots of your child with a busy background and another without it. To profit from this experiment, you must be able to look with a very critical eye at your photos. In portraiture, being careful of backgrounds is a subtle but important business. Don't disregard it.

When talking about having a pleasing background, we are really discussing the setting or environment. So in addition to the background, the foreground will play a part in making the setting of your photograph more or less harmonious. Understand that anything that takes your eye away from the child is a distraction. Look at twin brothers Willie (A) and Charlie (B) in photos 6-1. When Ted, their father, brought Willie downstairs, he asked me if Willie's striped shirt was okay for the photos. I replied, "Perfect; it helps me show the wrong sort of pattern to use." There was no insult intended, or taken, because Ted had seen me work over many years and understood the purpose of this book. When I made that comment, I didn't mean that stripes are a villain. I'm reminded of the diets that outlaw certain foods—for example, "Bananas are bad." Bananas can be good and so can striped shirts, but only in the right context: All things in moderation.

61

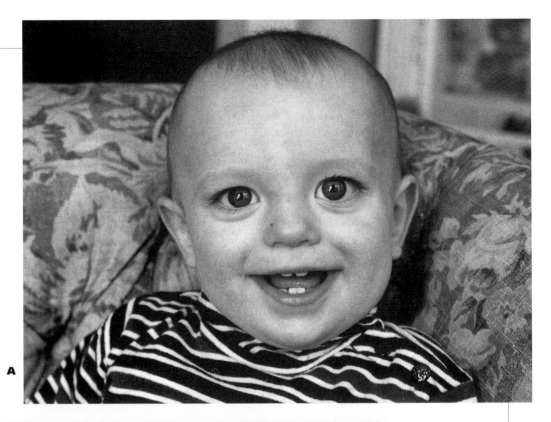

[6-1] The pattern of the chair upholstery plus the hearty stripes in Willie's shirt (A) distract from his face. In Charlie's photo (B), the plain sofa and less-strident stripes allow you to see his expression immediately. It is much more successful.

A

[6-2] What's wrong in these pictures? Or put more nicely: How would you improve them? First, try to get a sharp focus on the baby's face, so the foreground and background don't overwhelm him (A). The focus problem was probably caused by the camera not being capable of focusing so close to the subject. (All the more reason to check your camera to see what focusing distance it can handle, before you spend time photographing your little ones.) Even the chaotic confusion of toys and striped shirt might have been charming if Charlie's face were sharp. If your

B

camera allows close focus, then go closer still, so that the toys are less prominent and even slightly out of focus, and use them to frame Charlie's face.

In the photo of Willie with his father (B), not only are both of them out of focus, but the background is cluttered. And through the unfortunate quirk that often happens when the camera isn't focused on your subject, the sharp elements in the photo are behind the subject: the arm of the sofa and the checkered car seat to the right. One solution for this photo would be to have sharper focus on the people and move to the right, so the father and baby have a less-cluttered background.

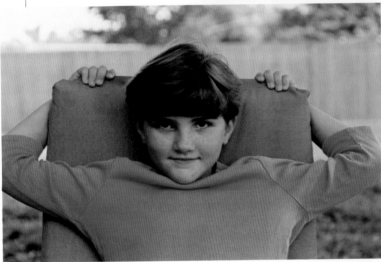

[6-3] The light on Maggie's face is good in all the photos, but only the last shot really gets rid of the distracting background enough for the viewer to concentrate on the expression on her face and the detail in her eyes.

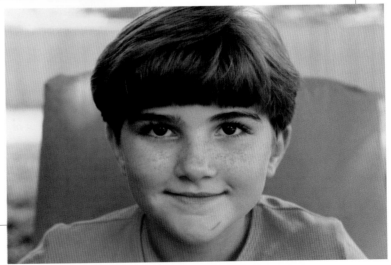

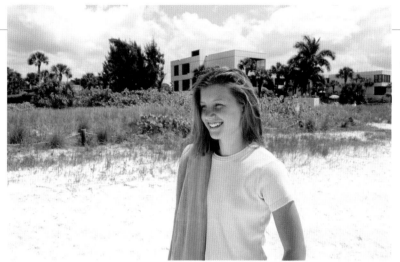

A

B

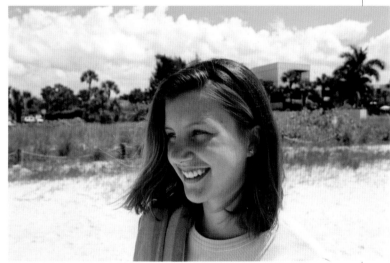

C

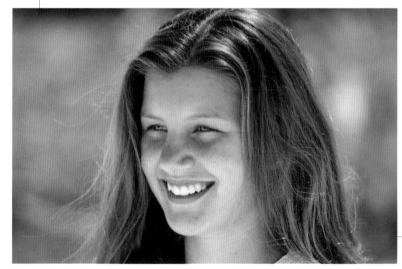

[6-4] In photo C, the background which is so unappealing in photos A and B disappears into a nice blur through the use of a longer focal length. Though the background in photo C is an improvement, one must admit that the light on Caitlin's face still isn't ideal. The glaring light of the beach makes her squint slightly.

[6-5] These children were photographed with a moderately long lens, 135mm. You can see the trees blurred into a pleasing background.

Stripes or other patterns may work if they are the only texture in the photo, or if they are shown as a very small percentage of the photo (as you see in Charlie's shirt). You can contrast the photos of Willie in stripes on a patterned chair with a photo of Charlie against the plain sofa. Isn't it obvious to you that your eye goes to Charlie's face, and his dear expression, just a little more easily than to Willie's? Read on—I hope to make you a believer.

Elements of Background

The things that add or detract from photo include busy patterns, clutter behind the subject, clutter in front of the subject, splotchy or harsh light, distracting color, and wardrobe that clashes with the surrounding. The photos in 6-2 show the twins again, but this time in photos taken by their grandmother. The toys in the walker so overwhelm Charlie (6-2A) that only a doting grandmother could appreciate the child amid the toys. The solution would have been to go in closer, so that his face dominated the photo instead of the gimcracks— or to choose another location. It would also help to have the child's face in sharp focus. Then, in the photo of her son and grandson, Ted with Willie, the background distracts considerably from the people. The car seat with the checkered pattern is almost as prominent as the people. One solution would have been to move slightly to the right, so that father and son were framed against the sofa background. Another would be to use a long lens, as explained later in this chapter, to make the background go out of focus—and then to make sure the focus was on Ted and Willie. Not that these snapshots aren't well worth having— it's just that they could be more successful with an increased awareness of background.

Wardrobe

As you saw earlier with Willie in his striped shirt, the clothing on your models influences the photo. Watch what people are wearing. If the clothing will detract from the photo and you have the opportunity, change it. Try to make sure that the child's clothes don't clash with his surroundings. If a parent is holding the child, avoid having intrusive patterns on both of them. Busy designs can reduce the impact of the child's face. Even hairstyles can distract. When you get to chapter 9, take a look at Carly in 9-9, with and without a headband. Keep everything, background and foreground, simple and clean, so that what shows through are the child's expressions—most of all the eyes.

Solutions

To avoid distracting backgrounds, one easy solution is to move. Look around for an area with a nice background where you can park the child. That's not hard when children are young and still contained in a chair or stroller. An older child may be cooperative about moving to another, more preferable background. But it can be difficult to bend the iron will of the two- to four-year-old group. You may have to use subterfuge to convince them that they want to move to where you need them to be. If that fails there is always bribery. Later in this chapter, you'll see ways to set up a small studio set, which creates a good background for portraits.

A

B

[6-6] The contrast of Sara's light coloring against the rich black background creates a dramatic and satisfying photograph. Now see a case where this approach doesn't work. Photo B is a mistake. I thought the light on Brandon's face would be pleasing, but forgot that his dark hair might blend with the background. It's a less-successful use of the dark-background technique. I should have noticed it, found a lighter background, or pulled him further out of the doorway into the light. (If you work in digital, the background can be fixed quite easily.)

68

A

[6-7] This yard is a delightful play area for the three children who live here (A). But at first glance, it appears too busy for photography. Can you find the child? How do you get a simple background? You can almost always find an area free of distraction—or use a long lens to blur the background (B).

B

69

Lenses

When you aren't able to move to another location, it's the long lens, or telephoto, to the rescue. If you are stuck with a location, for whatever reason, and the background is distracting, you have the option of using a long lens, which diminishes any annoying clutter in the background by throwing it out of focus. The distractions are then softened into a neutral and pleasing blur.

A word about lenses. (We touch on lenses in chapter 2 and chapter 11. Here we look at lenses only as they affect background.) As a general rule, the "longer" the lens, i.e. the greater the focal length, the softer the background. And the reverse is true—with a wider lens more of the picture area will be sharp and clear, including the background. Photographers and camera manufacturers consider a 50mm lens to be the normal focal length for a 35mm camera. It's the starting place.

What we call "long lenses" are lenses with greater-than-normal focal lengths—90mm, 105mm, 135mm, and up.

Wide lenses, also called wide-angle lenses, have shorter-than-normal focal lengths, such as 35mm, 28mm, 24mm and lower. You'll see more about the effects of different lenses in chapter 11.

When using a long lens, the subject you focus on will be in focus, or sharp, while the background will usually be blurred or out of focus. You can get an out-of-focus effect similar to what a long lens provides by using a specialty lens, the 60mm, also called a close-up lens. This lens allows you to get sharp photos up to a very few inches from a subject. However, in order to clean up the background distractions and gain the blurry background effect you want, you will have to work close up, literally right in the child's face. That may not always be possible and not always easy with older children.

Making the Best of Your Background and Light

In the series of photos in 6-4, Caitlin was smiling at the antics of her cousins as they got ready to leave the beach. I was standing in the same spot for all three photos, just using different focal lengths on a zoom lens (28mm, 50mm, and 105mm).

The first two photos are very unappealing, because they have a busy background glare from the sand and splotchy light on her face. The third was still off the mark because of the slight squinting in Caitlin's eyes caused by noontime glare. But at least using a longer focal length (105mm) minimized the distraction of the background by throwing it out of focus. But taking the photo in open shade would have allowed her eyes to open more naturally. It's a slight improvement in the background. So when you're in an environment with a busy background, you can turn to one of the simplest photographic tools, the long lens.

Doing the Same Thing in Open Shade

Open shade provides gentle, soft light—perfect for this group of portraits of Maggie in 6-3, so there isn't the same problem of harsh light encountered in the beach scene with Caitlin. But the background here in Maggie's photos is undistinguished at best. It would be nice to eliminate it. Photo A is shot wide with a 35mm focal length, so you can see the

background. Photo B, medium width, was shot with a 7omm focal length; this helps min-imize the distracting background. Photo C, taken with a 6omm close-up lens has minimal background and pleasant light.

A word about styling. Though the posture and wrinkled shirt are not conventional for a portrait, letting a ten-year-old be natural is more important than fixing the unruly T-shirt. This is authentic Maggie. Later, when you take a break, you can smooth the wrinkle if it really bothers you, or it may disappear on it's own when she moves her arms. Unnecessary fussing can squash spontaneity, forcing even the most cooperative child into a stiffness that might cost you a sweet expression.

By the way, I could have done a better job with this series if I had gotten a stool and had her perch on it. Then Maggie would have been framed by the leaves (see them in the first shot?)—it might have been an improvement over what I did.

Control Background with Light

Creating a dark, velvety rich background with the subject bathed in light can be a very pleas-ing and easy solution to a busy background. It's particularly successful in black and white, but also works well in color.

The technique was mentioned in chapter 5, but to recap, you simply find an area, such as a doorway, where there is a dramatic difference in the amount of light on the subject—background dark and subject bright. Set your child on a stool, in a chair, or any other place that positions her with optimum balance between light and shade. Avoid having the sunlight hit your child directly. You'll see that when the light of open shade falls on your subject and the background goes black, you have a dramatic photograph that successfully eliminates background clutter. You can see in the picture of Sara (6-6A) how well she stands out against the dark background, and in the photo of Brandon (6-6B) an unsuccessful example.

How Good Is Your Home Location?

Don't despair that you don't have the right yard or right location. You can always find a space for portraits. Any family with three children would be lucky to have the backyard set of playthings in photos 6-7. But at first glance you might wonder how to find an uncluttered background. Both are busy with friendly, colorful clutter. However, you can usually find a corner in any yard with leaves or other simple textures. Or better still, include some of the equipment in the photo by following the action, as I did when Alex was on the jungle gym.

Unlikely Backgrounds

A busy location such as a restaurant may not seem an ideal spot (or time) for photography. As we saw in chapter 5, restaurants, cafés, and coffee shops have the potential for good win-dow light. So keep in mind that what looks like a dreadful background may yield a lovely close-up.

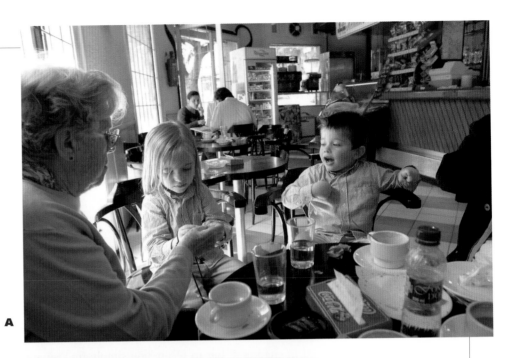

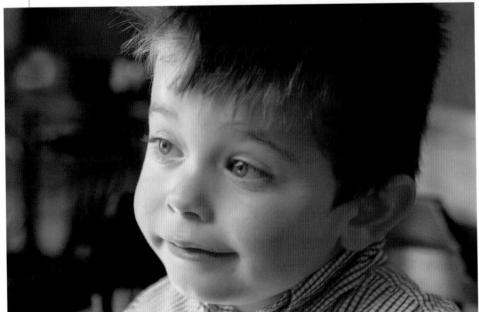

[6-8] This location, found while stopping for a snack with the children, might not appear promising. Between the cookie crumbs, restless children, and a waiter bringing and removing plates, why would anyone take this moment for photos? Look at the glowing light from the window at left—even in the large, cluttered scene it bathes the entire café and gives a sidelight to the children (A). Then see the portrait of Marc (B), which took advantage of the light and location, but required the use of a close-up lens to tame the background.

[6-9] These two photos of Native American children were from a photo assignment for a publishing client. They show two different approaches to color. The boy carries color in his headband and shirt against a subdued background. Here the color works to keep our eye on the boy. In the next photo, the brilliant pattern behind the girl works to make the point for my assignment, but might be distracting and too overwhelming for a portrait.

A **B**

[6-10] In photo A, the New Mexico landscape dominates the three children. They are recognizable to a parent, but to any other viewer they are three figures bathed in the golden afternoon light. They almost merge with the landscape. Photo B, Edith in the tall grasses, achieves a balance, because she is integrated with the landscape in a pleasing way. These are the times—when the setting is special—to take advantage of the lovely environment and bypass the super close-up generally advocated.

A

[6-11] Occasionally there are photos where the setting is busy but good. First, we see two of the Mullen Triplets in their playroom environment (A). The photo gives a sense of their world. In later years, when the family leaves this apartment for a house, the detail of this living room converted to triplet's playroom will bring back fond memories. The photo was intended to show the environment. I don't find it distracting, because the details don't compete with the children. They create a mosaic and the children are part of the pattern. Next, look at Jane in photo B. Here the background has equal billing with Jane and her cat. The morning light and exquisite detail in the gate blend for a photo of Jane's environment that works wonderfully. To me this is a busy background that isn't busy. There is no conflict between the child and the background, because the child is subordinate and the ambience is created by the busy but beautiful details. These photos contrast with the cluttered background in photo 6-2, where the background truly distracts from the people.

When Clutter Can Work, Or Times to Break the Rules

What's the difference between a scene being merely busy and distracting, or being busy and rich with detail of the environment? It may be in the eye of the beholder, but I think you can see the difference in these sample photos. Hold yourself to a high standard. Learn to recognize during the editing process what you've captured in a photo. Do you have a busy background which renders the photo good enough for a snapshot remembrance but probably not suitable for a blow-up prominently displayed in a frame or album? Or do you have a picture that catches

B

the ambience of a child's realm, where the background is an integral part of the subject of the photo? These photos, compared with earlier pictures in the chapter, show the difference.

Color

Just like shape and texture, color can either create pleasing elements or be a distraction. Try to tune yourself to recognize color that catches your attention in either a positive or negative way.

A

WALL C *opposite light source*

WALL B *right angle to light*

Child

Camera

WALL D

WALL A *open garage door; main light source*

B

[6-12] With Erin's family, we made a very basic set in their garage in about fifteen minutes. The starting point was a drop cloth to keep Erin away from greasy spots in case she sat down or touched the floor—not unlikely for a toddler. Next we rigged a white bedspread on the wall (which I thought was unwrinkled, but you'll see offending creases in some of the wide shots). Duct tape will do the job of fastening the cloth to most surfaces. I often use the even stronger gaffer tape, available in most photo-supply houses. Be careful, though, when pulling tape off afterward, as you can also pull off paint or wallboard surface. Metal pushpins also work. If you plan to use your studio space often, you can put nails or hooks in the wall and hang the fabric from those.

Since I planned to shoot only close-ups of Erin's face, I allowed some disarray in the floor-level cloths (A). But you could do a neater job, if you prefer. With that done, placing the child on a little stool or in a walker would give you the opportunity for a full-figure shot (B). You'll notice there is a slightly off-white, textured look to the cloth background in the photo of Erin wearing a lavender shirt (C). The photo of Erin in pink (D) has a clean white background. In that photo, she was against the foam core board. You can take your pick. Use foam-core boards on both walls if you prefer the look. You can try different types of cloth in neutral colors if they don't clash with the child's clothes. However, I prefer a white backdrop, since usually you have all the color you need in the child's clothes, and white has the advantage of reflecting whatever light is available, raising the overall brightness. At the same time, white provides accurate, clean skin tones. You can see a distinct difference in light in photos C and D. The main advantage of building a set is that you can take superb close-up portraits on a regular basis—once a month, for example—with minimum disruption of your daily life. You'll get efficient backgrounds, perfect light, and excellent photos.

C

D

Landscape Background

If you are with your children in an area of great natural beauty, whether at home or on vacation, consider this different approach. Instead of portraits, try some photos that feature the landscape, with your children merely as participants in the photo. They will become elements in the larger vista, no less important for the subordinate role they seem to play. If you want to bring the children to more prominence while still maintaining the power of the landscape, then go to a medium shot, which integrates them in the land (see 6-11B).

Creating Your Own Background Studio

With a very little bit of effort you can make your own backgrounds. You'll find two benefits to building a home studio set. The first is that you can provide a clean background for your portraits, one that is readily available when you have the time to shoot. The second is control of light, because you can create a lovely soft light without any costly strobe equipment.

Location for a Set

You might find a garage (with the door open, to let light in) will work best (see 6-12), but a porch, lanai, or sunroom with large windows can serve the same purpose. The background can be a plain piece of cloth or a large sheet of foam core. If you happen to have a tent without sides, that can be made to serve. A tent creates a lovely shade, then you simply design the background, which might be cloth, foam core, or even out-of-focus foliage. Just be sure to secure the background—clamps will do—against gusts of wind.

Materials for a Set

Start with plain, unwrinkled cloth fabric, such as a bedspread or curtains. You can invest in other fabrics once you've had some success with your techniques. Start with white, which has the reflective power to make more out of the light you have. White also keeps colors clean so that skin tones are natural. Later, you can experiment with gentle color backgrounds or some textured fabric, just as portrait studios do. It's good to have a drop cloth handy to protect the floor of your shoot area—or protect the child from the floor.

White foam-core boards provide another clean background. They are available online, at art or photo supply houses, or building supply stores such as Home Depot or Lowe's. As an added light source, you can use a 4' × 8' flat of silver-sided insulation as a reflector. If you get ambitious, buy two sizes of white foam core and one silver reflector. You can cut these down to a manageable size to use as reflectors in outdoor shooting (see chapter 5).

Where to Set Up

To choose the location for your set, consider the best light source as the starting point for planning. Look at the diagram in 6-12. If you plan your set as a rectangle, the wall with the light source is wall A. In a garage, your wall A is simply an open garage door (in a sunroom, it's the wall with the most windows). Wall B will be at a right angle to wall A, and therefore at a right angle to your light source. This will be the primary background for the por-

78

trait, because in most cases you'll find that the side lighting resulting from this arrangement is most pleasing. Wall C is opposite wall A.

Wall C, the third wall, is constructed with a large, white foam-core board. This board reflects the light back to soften the shadows on your subject's right side, and also gives another shooting background. This is especially helpful when a child squirms around or her attention is caught by something outside the door. In that event, you don't have to harangue the child with instructions about which way to turn; you just move yourself, following her movements, and you'll still be shooting against a clean background. Try to prop your foam core as vertically as possible to catch maximum light. You can use a sawhorse to hold it in place.

Using a fourth wall is a possibility but I don't see the need for it, partly since an escape route is highly desirable. But, if you wanted another wall, you'd have wall D, another area at a right angle to the light sources. You could use a silver-foil reflector board to bounce even more light. Just be careful not to flatten the lovely sidelight you've carefully designed with your right angle. That can happen if you add too much additional light and defeat your purpose of a gentle, modeled sidelight.

Be sure to choose a time of day when bright light floods the area, but when the sun does not actually reach wall B and your subject. If the sun reaches your subject, you have the same problem as in outdoor sunlight—a child making squints and grimaces (see 6-12).

Any background must serve your goal of revealing the vibrant personality of your child, allowing it to come alive through the medium of a photograph. Think of a photographic background as the setting for your jewel.

Capturing Action

Children are all action. They are full of energy and movement, including those moments when they may appear quiet.

For you as the photographer of record, the trick is to understand what types of action you'll confront when you spend time with a child. In this chapter you'll learn photographic techniques that will help you become most successful at catching those different kinds of action on film.

Types of Action

Action photography can be interpreted as catching an activity that is dramatic and fast moving, such as swinging on a jungle gym, running through a field, or playing a sport. That's how most of us think of action photos.

But with children there is also a more subtle type of action, smaller in scale, which can be just as challenging to a photographer. This includes, for example, the action of a toddler taking tentative steps in a backyard, a baby squirming around in a high chair, or the rapid movement in an infant's eyes when she looks from one person to another. When you are trying to focus close up on a baby's face, those actions are just as daunting as trying to photograph the most hotly contested 100 meter race. In children, any movement is action for which you must be prepared, both mentally and technically.

Anticipating Action

You can avoid the frustration of missing good action shots by preparing yourself mentally to be ready. It's common for people to approach photography by waiting until they see the ideal expression, only at that moment raising the camera to frame the photo. But by then the

shot may be gone. In that instant the child may have turned away, changed expression, or run right out of the frame. This is probably why many parents force children to freeze in place for a photo, often with the less-than-evocative results.

Follow the Child

My best advice for being ready for any action is to watch the child *with* the camera up to your eye. Try keeping your camera to your eye for a much longer time than usual. Use the camera as if it were binoculars, viewing constantly as the child moves, turns, pauses, and moves again. Stay with him. Follow, follow, follow with the camera in place and you'll be ready for the perfect moment. Looking through the camera at the child will help train your eye to recognize and anticipate a pleasing moment. The right moment is what action photography is about. It illustrates what the famous photographer Henri Cartier Bresson called the "decisive moment." That's his term for the most pleasing or informative instant of action. Looking for the decisive moments in your child's life is the first step in understanding how to catch action. Mastering the technical skills for stopping action will come later.

In the photos of baby Greg (7-1) wandering around the yard, you see there is the one moment that provided the best picture: it's when he paused just before smelling the flower. His concentration on the plant at that instant, all the tension in his little body, and the flower in his hand, combine to make a poignant moment.

The reward of following the action with the camera can be catching such a quiet gesture at the moment the toddler is poised before picking the flower. If you have missed it, asking the toddler to "do it again" probably won't help. Those quiet moments have to be captured as they happen, by following the action.

That photo may seem so natural as to be unremarkable. But look at the contact sheet of other frames and you'll see how uninspired they are. The practice of following the action allowed me to catch the gesture of Greg gently leaning into the flower that I might otherwise have missed. Catching this type of action doesn't require extraordinary technical ability or equipment. It does require a heightened sensitivity to the child's movement and a carefully honed skill at watching, which is the essence of photography. As an early teacher advised me: Follow, follow, follow; shoot, shoot, shoot.

It will soon become apparent that a sizeable number of photos are needed to capture action. But the resulting photos are worth the expenditure in film, or the time and effort put into taking numerous digital photographs. The next chapter makes the point even more emphatically—taking a lot of pictures will increase your chances of success.

High-Speed Action

To photograph a fast-paced activity requires building skills akin to those of a sports photographer. You need to develop a sense of timing, understand the use of different films, and understand the shutter speeds on your camera, so that you are able to do what photographers call "stopping action." With stopping action, the camera freezes the movement of the subject.

The three ways to produce a properly exposed picture are shutter speed, aperture (f-stop, or lens opening), and film speed. All three affect the sharpness or blurriness of your photographs. There will be an explanation of the interrelationship of these three technical

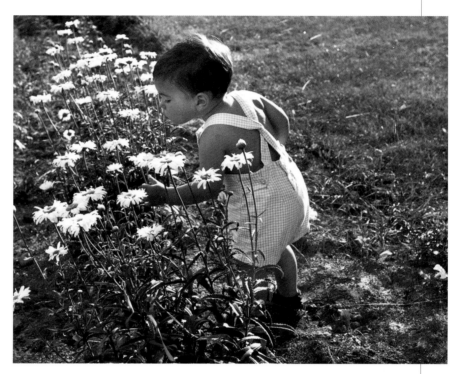

[7-1] The first four shots on the contact sheet of Greg were unremarkable, but the last was worth watching—and waiting—for.

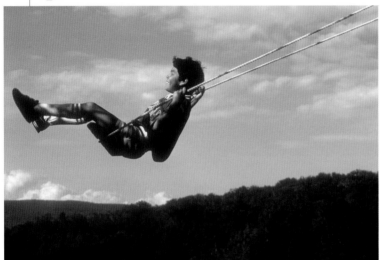

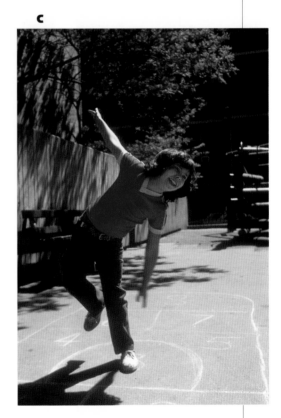

A

B

C

[7-2] These photos are successful in stopping the action in their respective lighting. The photo of Eric jumping (A) was shot at a shutter speed of 1/500th of a second, because there was ample light at the beach for such a fast shutter speed. The photo of Jeremiah (B) was taken with a shutter speed of 1/250th on a bright sunny day. The hopscotch picture (C) didn't present enough movement to make stopping the action difficult at 1/125th of a second with the average amount of light in the playground.

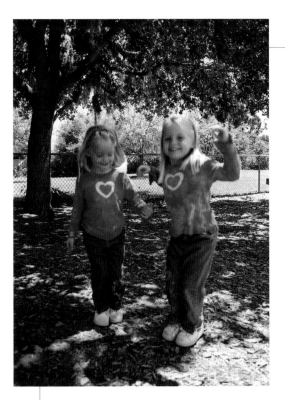 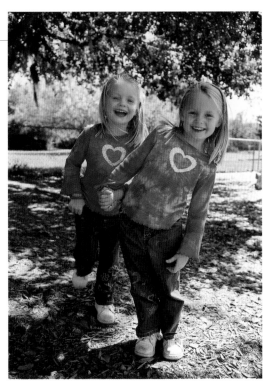

[7-3] As long as they were squirming and jumping, the twins were not going to be sharp in the shady, low light with 1/60th of a second shutter speed. I allowed them to let off steam, knowing the photos wouldn't work as long as they were jumping. I waited for the moment of pause, when they were quiet enough not to be blurry but still full of energy.

factors in chapter 11. Here we will touch on just the basics you need to understand action photography.

Film Speed

The film you buy is available with varying sensitivity to light, commonly called "film speed," and expressed numerically as an ISO rating. The ISO rating on a film carton will tell you if the film is slow (25 to 100 ISO), fast (200 to 400 ISO) or very fast (800 to 3200 ISO). Many digital cameras have an adjustment that increases the camera's sensitivity to light, just like going from a slow to a fast film. Film speed, as you'll see later, is one element in determining if you have enough light to stop action.

Shutter Speeds

Using a fast shutter speed is the primary method for stopping action. Fast shutter speeds are those greater than 1/250th of a second. Some high-end cameras have shutter speeds as fast

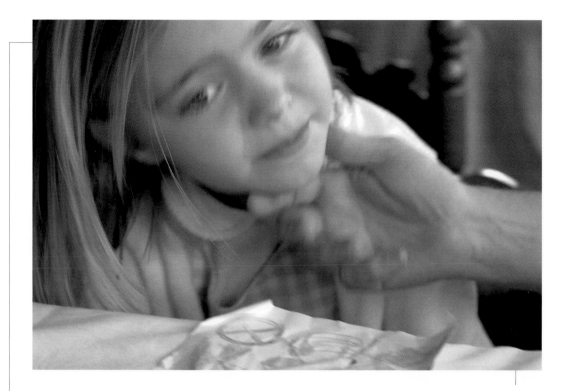

[7-4] Even though it is blurry, the tenderness of the gesture gives strength to a photo that doesn't measure up on merely technical grounds.

as 1/8000th of a second. The shutter speed you choose will affect your ability to stop the action, but this in turn is affected by the amount of light you have in a scene.

The more light you have—that is, the brighter the scene—the faster the shutter speed you can use and still have a properly exposed picture. With more light, the shutter can open and close quickly, because it needs only a fraction of the available light to still get an accurately exposed picture. Using a fast shutter speed helps you to take non-blurry photos that stop almost any action.

The less light available in the scene, the slower the shutter speed you will need. If you are working on a slightly cloudy day, in the shade, or indoors near a window you will have less light to work with for getting a good photograph.

Remember that at 1/60th of a second, the shutter lets in light for a relatively long period. The speed of 1/60th is the slowest speed advisable for stopping normal activity in children. If you use a slower shutter speed, such as 1/30th of a second, you may get blur from the hand-held camera shaking, as well as from the child's movements.

Comparison Shutter Speeds for Stopping Action

The photos in this section show the results you can get from a range of shutter speeds—fast, normal, slow, and very slow. Conventional advice in photography is that 1/125th is a safe

shutter speed to use in most situations, assuming of course that there is enough light. All the photos below were taken with film or digital setting of ISO 100. Look at the photographs to see the effects of different shutter speeds. (How film speed affects the photos is covered in chapter 11.)

Bright Light

As the picture 7-2A makes clear, for Eric jumping in the waves I had lots of light. This brilliant light allowed me to use a very fast shutter speed and a small aperture. There is no blur. He is frozen in space at the instant of his jump, clearly showing the droplets of water and even the ribs on his lean torso. In the photo of Jeremiah on a swing in photo 7-2B, though not so dazzling, there was enough light to use a fast shutter speed and still catch him on the top of his arc against the sky.

Average Light

The medium-bright light you encounter on many days will usually handle moderate action. So the action of the girl playing hopscotch (7-2C) was stopped with a medium-fast shutter speed. She was moving, but not with the same vigor of Eric at the beach or the speed of Jeremiah on the swing.

Low Light

Next is a set of photos taken in open shade (7-3), with much less light than the previous scenes. It's a light I find very appealing, but low light does make it more difficult to stop action. Since there wasn't enough light under the trees to allow me to use a fast shutter speed, I worked at 1/60th of a second. Even when light is low, you don't want to inhibit the children. As you see, the result is that you may lose some photos to blur. Be ready to edit your photographs and throw the blurry ones away. Losing some photos is a small price to pay for a few good ones. (Firmness and discipline in editing is critical, as you'll learn in chapter 8.)

In photo 7-3A, you can see the blur as the twins were jumping about. Then in the moment they paused (B), there is a sweet photo that is not stiff. The slow shutter speed caught the scene, stopping the movement of their arms and hands but not all the feet. See the one blurry foot? That slight blur is not detrimental to the photo and simply reinforces the sense of movement. It was worth the blurry shots to get the one good photograph as they paused, with their liveliness still brimming over in their body language.

Very Low Light

Look at the completely blurry photo in 7-4. You don't want many like this. Generally they are useless in terms of representing your child, unless an evocative moment is preserved that would not have been captured any other way. The affectionate gesture of her father's hand on little Gloria's chin was worth attempting to photograph and, I think, worth having because of the sweet moment it captures.

[7-5] Take a look, first, at the chapter opener photo of Theo hurdling, which was intended as a blur. I used the panning technique to follow his action with a slow shutter speed (1/15th of a second). The purpose was to heighten the drama of his movement. This hurdling photo stops the action with a 1/500th of a second shutter speed, freezing the motion and catching his look of determination. When you have the opportunity, it's good to vary the style to see which you prefer.

It happened so fast that I didn't have time to think if the shutter speed would capture the action. The photograph was taken at 1/30th of a second in a restaurant with very low light, and both of subjects that were moving. You can actually get a fairly clear, non-blurry photo at 1/30th of a second if your hands are steady and the subject isn't moving. In this case, the father had been cajoling the girl out of a disappointment and reached over to chuck her under the chin. They were both in motion at the time, causing the extreme blur.

Intentional Blur

Finally, you can try for a blurred effect to give a different impact to an action photo. Using a technique called panning, you follow a high-speed action with your camera, using a slow shutter speed. You follow the subject through the action, moving along with it, so that there is enough blur for drama but not so much that the subject is indistinguishable. This technique works well with children on bicycles or skateboards, engaged in action that they can repeat for you several times in the same space. They will gladly volunteer for this kind of photography. It takes a good bit of practice to master the panning technique, but it's a lot of fun. And for those of you who have children in sports, panning gives some variety to the pictures of your family athlete.

What Causes Blurry Photos?

Blur can be caused because the subject is moving quickly and the shutter speed is not fast enough to catch the action. Another reason for blurry photos is poor focus. If you don't focus on the main subject it will appear blurry or soft edged. Or blur can be a combination of these.

To diagnose what might have gone wrong in a blurry photo of yours, check first to see if everything is blurred. That might indicate a shutter speed not up to the task. If something in the foreground or background is clear and sharp but your subject isn't, then the villain is most likely lack of focus. There are times when all factors contribute to blur, but in the majority of cases it will be shutter speed or poor focus at the root of the trouble. (You'll see photo examples of blur in chapter 11 and learn about camera shake, another cause of blur. Camera shake most often occurs when you are using a telephoto lens in low light with a slow shutter speed.)

Flash and Shutter Speed

There are times when using a flash will stop action. In this photo of the three children performing at a school play, I used professional strobe lighting, which provided enough light to create a good exposure and stop the action. You can do the same if your flash is strong enough and you are close to the scene.

[7-6] The earnest performances by these children cry out for a nice photograph. If you can get close enough to the stage, your flash should stop the action. (Also use a long lens: 105mm or 135mm.) With your eye to the viewfinder, move along with your children to get authentic, candid moments in their lives. Capturing action will become second nature to you as you follow your child.

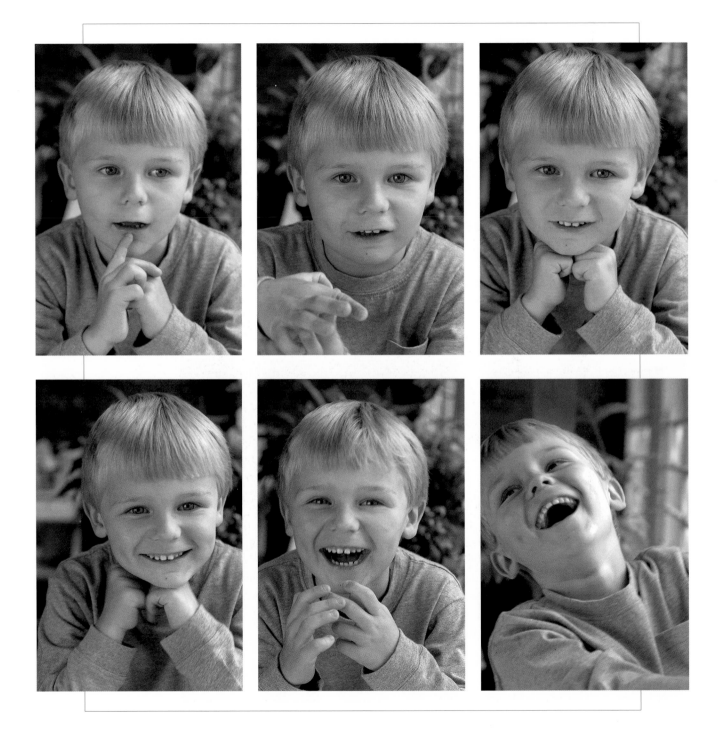

How Much Film Do You Need?

The gist of this chapter can be summarized in two sentences. Shoot a lot. Throw out a lot. To answer the question of how much film you need or how many digital pictures should you take in order to get great results, it's worth looking at how the professionals do it.

Have you ever watched professional photographers at work? You can often see them on television as they are covering an event. A good view can be had at situations such as Congressional hearings, where you can see a group of photographers lined up in front of a witness. At sporting events such as ringside at a boxing match or courtside at a basketball game photographers can be seen at work. Take a few moments to watch them the next chance you have. In particular, take note of how long they keep a camera to their eye. See how many frames they seem to be shooting. They don't shoot one frame and then stop. They continue shooting virtually as long as the subject is in front of them or there is some action to follow. That's the amount of usage you should consider.

Getting great pictures does have a direct relationship to how many photos you shoot. One of the common mistakes made by beginners in photography is to take one picture and stop. There's no avoiding the truism that the more pictures you shoot, the more good ones you'll get. Naturally, as your photographic skills grow, your percentage of good photos will increase.

Why Take So Many?

A news editor once said to me, "Why do you shoot so much film? Why don't you just shoot the best one?" In the stunned silence that followed I realized that there was no easy answer. Common sense would tell an editor that if you could predict which moment was going to be best, as well as *when* that moment was going to occur, it would be easy to wait for it, saving time, energy, and lots of film or space on the memory card in the bargain. But whether

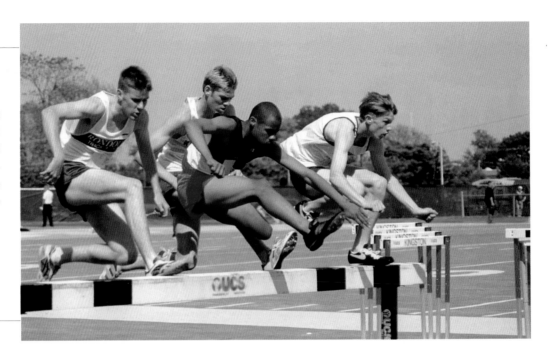

[8-1] It took at least sixty-four shots to yield this one photo where all the boys were nicely balanced and clearing the barrier at the same moment.

with sports action, Congressional drama, or the daily life of a child, moments of great interest often come upon us unaware. So being alert and ready is essential.

All that you've learned so far in this book will make you ready for what professional photographers call heavy shooting or in-depth coverage. Having mastered the techniques in earlier chapters for shooting with pleasing light, with a good background, and from an interesting angle, you are now able to take best advantage of heavy shooting.

There are several areas of photography in which heavy coverage is particularly important. If you are trying to catch action and expressions, or working in a variety of locations, that will translate into lots of film or many digital files. Here are some examples.

Action

When you are taking pictures of a fast-moving subject, you need to shoot a lot to catch the perfect moment of action, and you may have to do it often as the action in an event unfolds. In photo 8-1, I used a lot of film to get this exact moment when the four teenage runners are in suspended animation clearing the barrier during a 3,000 meter steeplechase race. Each runner is clearly visible, the expression on each face showing determination and concentration. But to get that one moment, I took a lot of film on each of the eight times they ran around the track and past my vantage point. As it turned out, I needed heavy coverage of each of those eight opportunities, because when editing the photos I found lots of shots that didn't work. Sometimes the runners were spread out too far for any sense of drama. Other times they went over the hurdle so bunched up that some runners were obscured. On only one pass did I get the shot I liked. I probably shot at least eight frames each time they passed, which makes a total of sixty-four shots to get the one I liked.

Photographing a baby clapping hands may require the same techniques of action photography used to photograph sporting events. You can see in the contact sheet of baby Marc

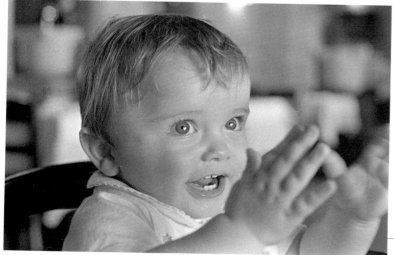

A

B

[8-2] Baby Marc was being entertained by clapping hands with his sister. Finally, after taking eight to ten shots, I caught a delighted expression without his face covered. You are almost never sure if you have captured the moment, so keep shooting until he stops clapping. Photo B shows an enlargement of frame 12 , which is my favorite. Frame 13 has some appeal, but Marc's thumb is too close to his nose.

how many shots were needed to get a really pleasing one. On many, his hands were in front of his face, so that the gleeful expression is obscured. The contact sheet shows that there are many rejects, some also-rans, but only a few really good ones. If you need a justification for shooting so much, the one I use is: Look how many I missed, but just look at what we caught. Even digital isn't a huge help here, since you want to continue pressing the shutter as long as the baby is delighted. Don't even take time to glance at the digital LED window on the back of the camera. A few moments later, you can review the digital photos to know how much you have caught. But at the time the baby is performing, don't quit until he does.

Expressions

The same need for heavy shooting holds true even when you are photographing close-ups of a child's face. Even if a child is contained—seated in a chair, for example—action is at work. Although he is not going anywhere, there is still a need to be alert for the perfect expression. There will be quick eye movements, slight changes in expression, and changes in posture that you want to catch. If you don't shoot a lot, you may miss the most exquisite moment. For one

93

thing, you don't know when that moment is coming (as I tried to explain to my editor). If you photograph a child reading, looking up, asking a question, looking puzzled, all in the same spot in the same few moments, those may be pleasant photographs. Then, at any given moment, you may find the child glancing up at you with a look of sheer delight. That's what you need to be ready to catch. You don't know when or if that moment will happen. It's all about being ready. And if, on that particular day, your subject never "looks up with delight," you still have all the other very good pictures. You can see in the series in 8-5 the value of shooting a lot at one moment in one location. What a variety of expressions you can capture a few minutes of heavy shooting. Don't settle for just one or two frames.

Locations

Another reason for shooting a lot is to try various locations and activities. When you have the opportunity to spend time with your special child, you should certainly take advantage of all the places available—to see which a child enjoys more or which provides the more pleasing background. You could try shooting on a deck, a porch, inside near a window, or in the yard. Some locations won't work as well as others, but it is still worthwhile taking the photos and using some extra film and shooting time in the process.

Look at the group of photos in 8-3 taken on a day spent with Petey. There were many locations that day that weren't as successful as the ones we've shown. When we tried working outside in the garden or on the hot, sunny deck, Petey wasn't happy nor was the light ideal. So those locations didn't contribute to good photos. But unless you try them, you might not be sure. Often, how productive a particular location or activity will be has to do with the child's interest or the chemistry with other family members at a given time. Shoot as much as you can in different locations until you find the ones that work. You want locations in which the child is comfortable and in which the light is pleasing. Even if you have limited time with your child, don't give up when one location doesn't seem to work.

Also, you might notice that the shots of Petey are medium close, not super close. That was because he was tired and feeling a little sick, not in the best frame of mind. I chose to stay back because he was cautious of me that day.

Baby as Still Life

What if the child is perfectly quiet; would you need a lot of shots? Perhaps not quite as many as in an action scene, but don't be stingy even with a subject that isn't moving. For example, a sleeping baby may seem like a subject for one shot only. Not so. After you've taken the obvious picture of the peaceful sleeping baby, then start looking for other approaches. Move around the baby, looking through the camera from different angles. See the way the light falls from each vantage point. Try medium and close-ups of the sleeper. Look for tiny fingers and toes to isolate in a photograph. In other words, explore the opportunity completely.

Editing

If you have become a believer that taking lots of photos is a good thing, now comes the painful part. It's time to throw pictures out—or at least a percentage of them.

Editing photographs means selecting the best, and getting rid of the worst and the merely adequate. In checking the dictionary, I found that one of the definitions of editing—to pare down—was especially apt. You can use any of a dozen agricultural similes to apply to editing photography. It is like skimming off the cream, separating the wheat from the chaff, weeding a garden, or pruning a tree to improve its shape.

And as with pruning, you will do more credit to your good photographs if you remove the just plain ordinary as well as the rejects. Whether you are showing the photos to friends and family, putting them in frames or in an album, if you include the rejects it will dilute the impact of your strongest work. Part of what I hope to accomplish in this book is to impart a sense of discrimination about the photographic quality of your photos of your children. It's not easy to keep an objective evaluation of photographic quality when you are overwhelmed by the warmth you feel for the subject of those photos. I still have a difficult time facing the reality that some photos are mediocre and can't be made better by my fondness for the child.

Emotional Impact

"You want me to throw out photos of my child? I can't do it."

Parents have actually told me that they would feel uneasy at the idea of throwing away any image of their child. They've said that it didn't seem right. You can hear a distant echo of the belief held in some cultures that photography steals a part of the subject's soul. It's not a feeling to be ignored. If you can't treat the images as just paper or film, then instead of actually throwing them out, segregate them. Remove them from what you display. Put the film rejects in a box in a closet or attic. Transfer the less-good digital images to a CD or DVD, mark them rejects, and store them in that same closet or attic. Just take them out of public view.

The significant aspect of editing is to identify the strongest photos and eliminate the obvious rejects or the simply boring pictures. It's not just your photographic skill that you highlight through a stringent editing process; it is the child you are showing off to best advantage.

How to Edit

You will develop your own techniques for editing, but you want to consider the aesthetic aspect as well as the logistical methods for selecting which photos to share or display. Professionals will actually throw pieces of film in the trash or delete digital files from the computer. Those photos are gone forever. It takes discipline and experience to reach a level of confidence that you can remove a photo irrevocably. If you have chosen the path of segregating, but not throwing out, photos, even the task of confining some images to oblivion in the attic may seem daunting.

Editing Criteria

The things to look for during the editing process are all the elements described in the early chapters, including these criteria:

▶ *Technical quality.* Is the photo clear and sharp, the light pleasing?
▶ *Mood and expression.* Is the mood interesting, evocative of the child's personality?

> ▶ *Simplicity of background.* Does the background distract from subject or enhance the photograph?
> ▶ *Interesting angle.* Is the perspective unusual or the viewpoint original?
> ▶ *Mistakes.* Are there unpleasant expressions such as closed eyes, a facial grimace, a tongue out, or awkward body gestures?

[8-3] On this day, Petey was at his best while we were in the house, having his snack or just after getting up from his nap. At first, he was cranky outdoors in the sun; finally he found the sprinkler and his spirits lifted again. And what was harsh light in the garden became nice backlight at the sprinkler. (It helped that I asked his mother to change the position of the sprinkler in relation to the angle of the sun to give us the better light.)

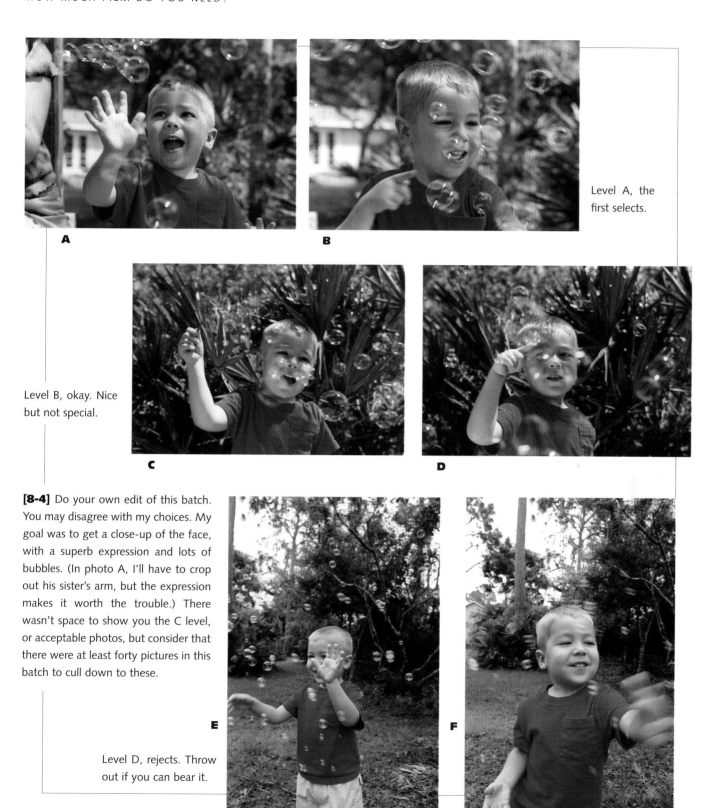

Level A, the first selects.

A

B

Level B, okay. Nice but not special.

C

D

[8-4] Do your own edit of this batch. You may disagree with my choices. My goal was to get a close-up of the face, with a superb expression and lots of bubbles. (In photo A, I'll have to crop out his sister's arm, but the expression makes it worth the trouble.) There wasn't space to show you the C level, or acceptable photos, but consider that there were at least forty pictures in this batch to cull down to these.

E

F

Level D, rejects. Throw out if you can bear it.

Editing Categories

You can make up your own ways of sorting your photos into categories, from the excellent photos to the rejects. Here is a set of categories to consider:

- ▶ *A level.* These are what photographers call "first selects." These are the best in every way: technical quality, aesthetic quality, and emotional impact.
- ▶ *B level.* These include good extras, photos that are technically fine, but not extra special. Some days this may be all you get. They are good to have, possibly delightful enough for the album, but not to be framed on the wall.
- ▶ *C level.* This is the toughest category to identify. They are technically okay but repetitive, ordinary, perhaps boring pictures. I call them the also-rans. You may not pinpoint what's wrong, except that they don't have the punch of similar shots from the same sequence. This is when you must be courageous and pull them out from the A and B levels, or you risk serious dilution of your efforts.
- ▶ *D level.* Rejects. Throw outs. These are photos where the eyes are closed, back turned, hair over the face, blurry without any redeeming emotion, way too dark, etc. This is the bottom of the heap, really not worth looking at again.
- ▶ *S level.* Snapshots. This is a category I have added for editing child photography. There are some pictures that have value even though they don't meet the standard criteria outlined. They are true snapshots and provide a charming memory of an event or a time together with a child, in spite of a low quality level.

As I was first writing this section, I thought that the S level was not used in professional work, but then I remembered that I have my own S-level photos when I edit a professional job. In my editing, the "S" stands for "send," meaning send to the client for the fun of it. Those S-level photos may be group mug shots of the clients and photo crew together at the end of the project, or other amusing views of the production. Your snapshots will fill the same bill, providing amusing or pleasing remembrances. Just remember that they are not the portraits you set out to capture.

Costs of Photography

For those who are using film, remember that if you are going to be cautious or a little bit stingy with film, you reduce the odds of catching the special moment. If you can afford it, indulge yourself with film usage. The pros know what and how to shoot, and they know how much coverage is needed. Sometimes you may get only a few good photos. At other times, there will be several fantastic shots, and the cost of the film will melt from your consciousness. The same translates to digital. Even though memory cards can be reused and therefore are not a major cost factor, there is an expenditure of time and energy shooting a lot of digital images. There is also the cost of ink cartridges and paper in the printing stage. Be generous with yourself. The child will grow and be gone before you realize it. Those moments don't come again.

When you are taking pictures of your child, consider that you are doing a photo story, that you are covering the life of your child as if for a documentary on a subject you love.

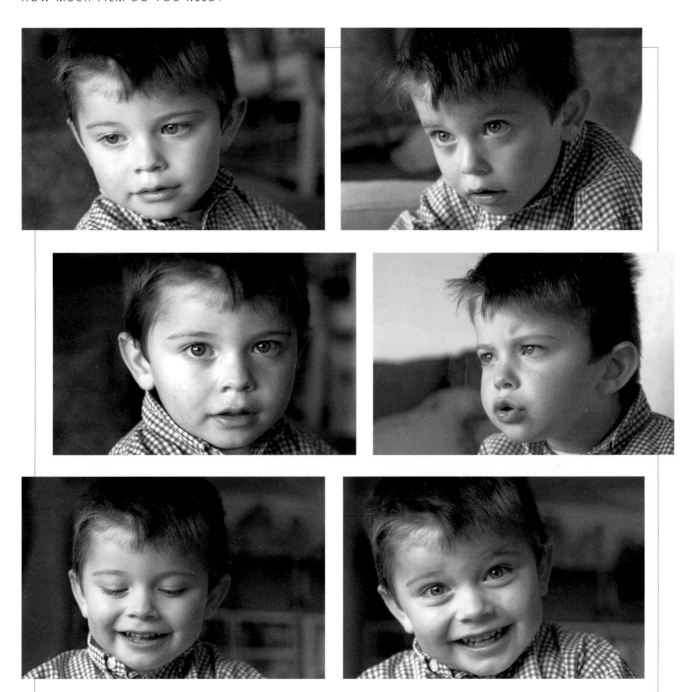

[8-5] Which of these expressions would you have sacrificed by not shooting enough? (Which of the additional ten or twelve that we didn't have space to show you would Marc's mother have thrown out?) Simply keep shooting when you have the chance, keep the conversation going, and you'll have a range of lovely expressions that are well worth the extra work.

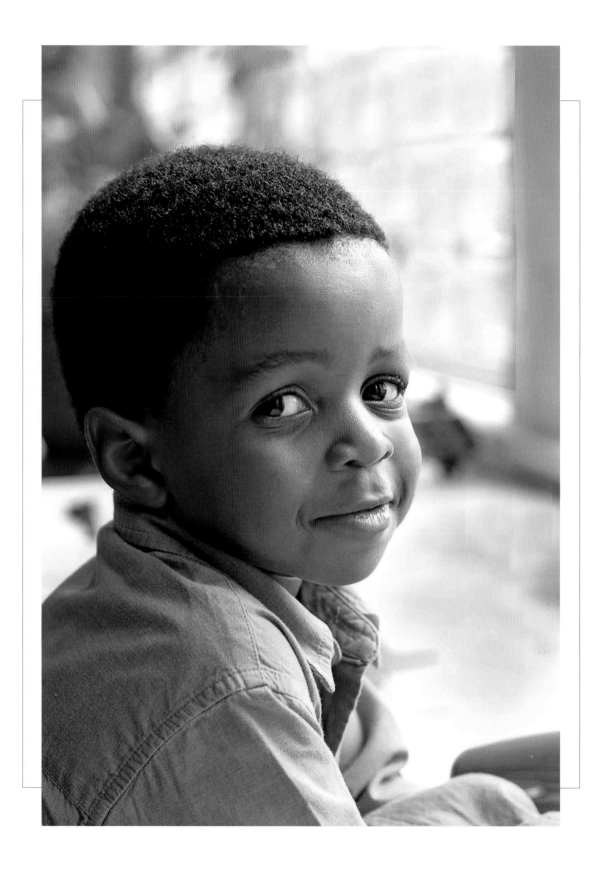

Tips for Photographing All Ages

In this chapter we tackle the psychological aspect of child photography. You have learned about lighting and backgrounds, but how do you keep your children relaxed and natural in order to get spontaneous portraits? And how do you keep them in one place long enough to do that?

Your task is to engage their interest in the photography itself, in you, or in some activity that offers the opportunity for good photographs. You'll see that there are approaches that work with most age groups. Later in the chapter, you'll find a summary with techniques specific to each age group.

The goal is to have a child look natural rather than striking a pose for the camera. If the child does look at the camera, you want an authentic expression, not one that is forced by your request or assumed just in an attempt to please you. Depending on the age of the child you are working with, you can accomplish this through a combination of distraction, honesty, trickery, sleight of hand, and luck.

Talking

With virtually all ages, talking is the single most useful technique to get a child to interact with you. Talking doesn't mean giving directions or instructions, such as "Look here, turn this way," or worse, "Give me a smile." Talking means conversation, discussing something that is of interest to the child.

What to Talk About

Ask the child to tell you about his world. But like any good interviewer, you should have questions in mind. Finding out what subject will work in a conversation might take some

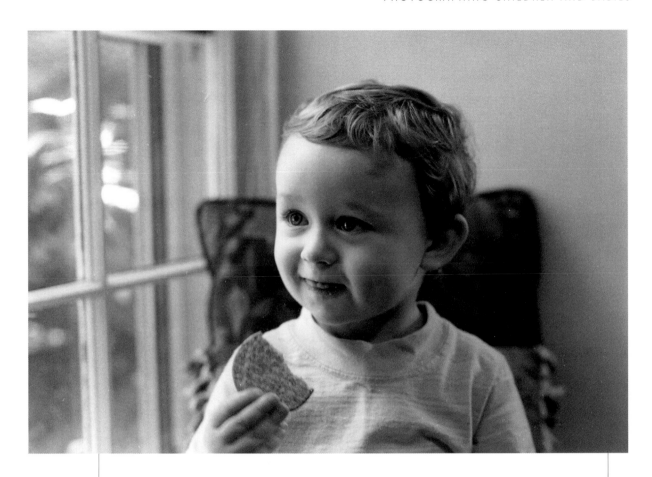

[9-1] Have the person helping you provide a distraction by talking to the child. Have that helper, parent, or sibling stand right behind you on the side nearest the light source (window) so the child will face toward the light (as well as the helper) as shown in the diagram. The light on Petey's face is perfect because he is looking toward his mother and toward the window.

experimentation. Questions will vary depending on the age of the child, as well as your familiarity with him and the family.

If you are the parent, you will know some topics or recent family events to start a discussion. And you'll know the child's interests in music, television, or school activities.

If you are a relative or family friend and spend time with the child only occasionally, your interview will take a different direction. You might ask about pets you know he has or activities of his siblings. Or what's new in school. Who are his teachers this year? Who is his best friend? Clues from the parents will help you get started. As you'll see, teenagers require a direct approach, such as "I'm asking you to talk about things so this photography business doesn't become boring for us both. So tell me . . ."

Where Should They Look?

When engaging a child in conversation for the purpose of photography, you have several options for where he should look. You can have the child look directly at you (which means into the lens, since you have the camera up to your eye). If you can sustain children's interest while they look at the lens, it provides wonderfully direct, intimate photographs.

You can also have a companion (the second parent, a sibling, or grandparent) help you keep the attention of the infant or child, and involve the child in conversation. If a child doesn't know you well, having his parent (or sibling or favorite babysitter) nearby will put him at ease. Use the parent to help with the conversation. Position the parent close to the camera, standing just at your shoulder. The parent provides a distraction away from what you must seem to a baby or child: a strange person with a black box in front of her face. But the parent helping you must be cautioned not to give instructions, simply help create conversation.

Position the parent or helper to the side of you where the light is best, so the baby will look up at her and toward the light at the same time. If the helper is on the side opposite from the light, and the baby looks away from the light, you will have deep shadows on the baby's face, obscuring any photo-worthy expressions. Generally you want to photograph a child at his eye level, so you want to position the parent helper at the same level. Otherwise the child will look up at the standing parent and your view will be simply under his chin! See the diagram and Petey's picture in photo 9-1.

An older, school-age sibling makes an excellent helper to distract or engage a toddler or young child. The sister or brother usually enjoys the importance of his or her role in helping you. Then, when the time comes to photograph the sibling, he or she knows the game and will be more open with you. You can tap into the camaraderie gained by working together. The world-weary, we're-two-old-pros-working-together tone usually strikes a responsive chord. Try comments like: "OK, it's your turn for pictures. You know the drill. We have to do this for your parents." Or, "Aunt Helen will never forgive me if I get pictures of the baby and not of you. So, what shall we talk about?" In this way you are being straightforward with the child, making clear that you need something from him. A sense of cooperation is usually well developed at this age and will stand you in good stead. (If the child is your own and familiarity has bred a little contempt to the point where he starts to balk at photos, see the end of this chapter for ways to handle that problem.)

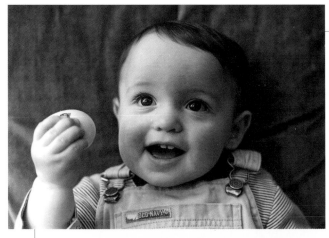

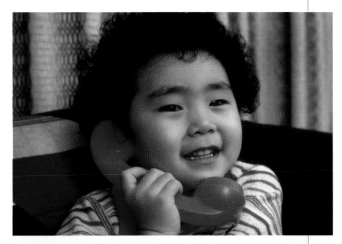

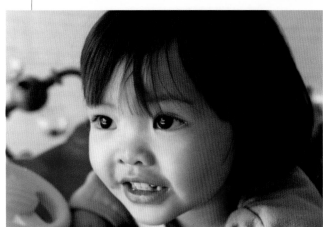

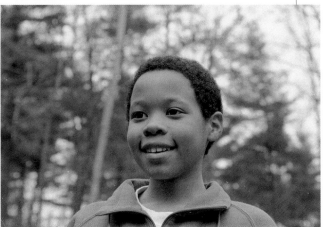

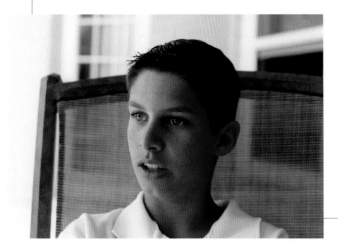

[9-2] These children—from ages eighteen months through fourteen years—became relaxed when having a conversation, providing sweet, natural expressions. Various distractions were used: the toy telephone and ball for the younger ones, to more serious conversation with the older children.

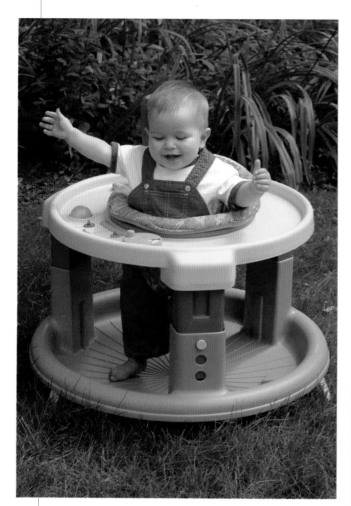

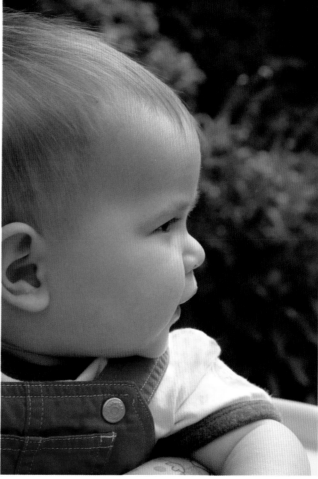

[9-3] Babies and toddlers are easily contained in walkers, high chairs, cribs, etc. For Ryan, putting his exerciser in the soft grass where he couldn't move it kept him in place and allowed for a close-up profile in soft light.

If you are a virtual stranger (perhaps a friend of the family that the child doesn't remember having met), you can start from scratch with your conversational gambits. When I was working on sample photographs for this book, I went to a day-care center run by a friend. I had parental permission to photograph the children, but no helper to distract the children from the fact that I was a stranger. After being introduced by their teacher, I went to the basic questions: Do you have brothers and sisters? What are their names? How old are they? What do they like to do? Do you have any pets? What kind? What are their names? If you are the child's aunt, uncle, or grandparent, improvise on what you know about the family and the child's interests.

Getting Attention

Babies and toddlers respond well to nonverbal distractions to keep their interest. A variation of baby talk and peek-a-boo from behind the camera is terrific with the infants. Usually this will elicit a range of expressions, including looks of anticipation, puzzlement, and then delight as they see you emerge again from behind the camera, perhaps making silly faces at them. Try to hold the camera steady, framing the baby's face. Then, even as your eye leaves the viewfinder, take the picture "blind," while you have eye contact. The resulting photo might be crooked or poorly framed, but it also may be a fantastic picture.

As mentioned in chapter 2, jangling noisy objects like keys and rattles usually intrigue babies. But you must work very fast to get your photos. Be prepared to surrender the object to the baby within a few minutes. Otherwise that distraction, if withheld, will become an irritant, not a delight.

A late toddler or preschooler can often be distracted (once conversation wears thin) by pointing out objects of interest nearby. Point out a clock, a bird, or the mailman coming down the path. The latter worked with Maya (see her picture back in 5-1). She entertained us both by enumerating everything she saw from the perch where I had set her by the window. And I sat, waited, and photographed, spending at least twenty to thirty minutes while she chatted, squirmed, and gazed down the street. It's really a very peaceful, pleasant time, sitting with a child. It's not just the photographs you get, but the experience that rewards your efforts.

Distraction for an older child can include letting her look through the camera—even letting her take a few photographs. (You should keep your hands on the camera if it's too heavy for the child to manage and could slip through her grasp.) If you are working with a digital camera, children will be delighted to see the results of their labor immediately. That can help them understand why you find it so interesting to look through the black box.

Containment

Keeping a child in one place is imperative when you work with little ones who are too young to engage in conversation. Later, once they have learned to move on their own, it's hard to keep them still enough for close-up face shots. When possible, take advantage of the times when they are in a stroller, a high chair, at a table—anywhere where they are confined. Use any place where they will concentrate on you, and not on trying to crawl to every corner of the room.

Having them controlled allows you to move them to a good light source near a window or into a nice shade. You can lift the stroller, high chair, or playpen (not used so often these days) to the spot you need for good light, as we did for Ryan in 9-3. Don't forget to take photos when they are in a crib, especially just waking up from a nap.

Use the opportunity of that half-sleepy, rested time—before they wake up enough to want to get up and out. Usually you'll have fifteen to twenty minutes of a sweet languor before they clamor to be taken out of the crib. You may remember the photo of Cassidy in her crib in chapter 2. Her mother and I had moved the crib about four feet closer to the window when she went down for her nap. Then, as she awakened, the light was perfect.

Activities: The Quiet Kind

Keeping children occupied and in one place can be accomplished by having them involved in a variety of crafts or games. While they are working, leave them alone to concentrate. You can photograph their moments of concentration, which are often pleasing representations of their personality. Capture the characteristic twitch of their mouth, tilt of the head, or a hand holding a paintbrush while they work. You might occasionally broach a question. Ask them what color they like best, what they are drawing, and so forth. But have patience. They will eventually look up and grace you with a glance of satisfaction or pleasure.

Consider photographing them doing all kinds of crafts, hobbies, and games: puzzles, Lego construction games, finger paints, drawing, and clay. And neatness doesn't count. Realize that when young children concentrate, they often put their noses to the work, with their hair covering the drawing and sometimes their face. You will get a better final photograph if you don't annoy them with inane interruptions while they are being creative. Instructions to "Look up" or "Get your hair out of your eyes" may defeat your purpose—just wait for a good photographic moment.

Having a child playing with a sibling, perhaps doing a simple board game like checkers, gives you opportunities for photographs with two children. They'll entertain each other while you work, alternating with photographs of each child, or backing off to get a shot of the two of them involved in the game.

Reading is always a great way to occupy a young child. The young reader will often look up from a book to give you or the person nearby an interesting look. You can ask questions about the characters in the book and the evolving plot.

Active Pastimes and Sports

The quiet activities described above are good for getting medium or close-up photos of expressions. But for a change of pace, or for older children, try photographing your children engaged in physical activities. All kinds of sports and games lend themselves to good action photos. A trip to a park or playground offers swings, jungle gyms, and teeter-totters.

Water sprinklers are a great location for exuberant action. Swimming, splashing at the edge of a lake or ocean, jumping in leaves, playing in the snow—all these provide action for one or several children in different seasons or geographic areas.

Let them run. Encourage a certain wild abandon. Allow them to be silly. Ask the six- to seven-year-olds how high they can jump. Have them hold hands at water's edge and jump

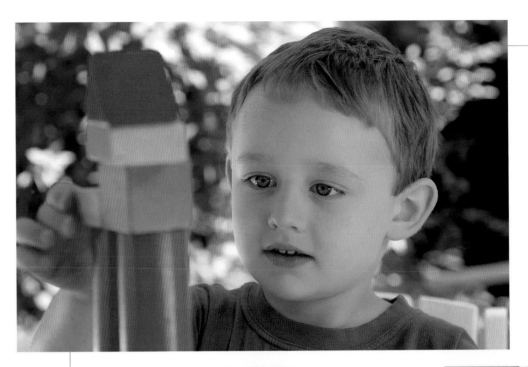

A

[9-4] These children allowed ample photographic opportunities while they were occupied with their activities. Petey's concentrated expression (A) provides a change from the usual portrait, and the picture of Jaron (B) shows a grace of movement you may not capture if he's aware of the camera.

B

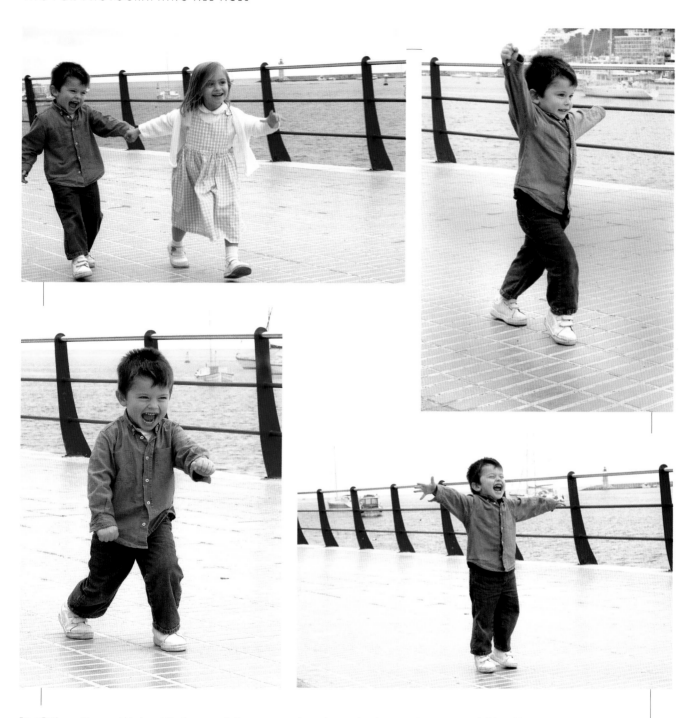

[9-5] The action and high-spirited moments in games and sports are clearly appealing. Young children like Gloria and Marc delight in Statues or similar games.

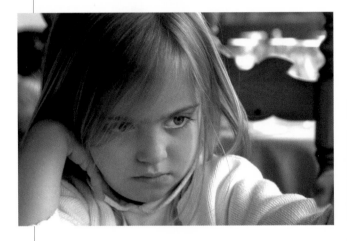
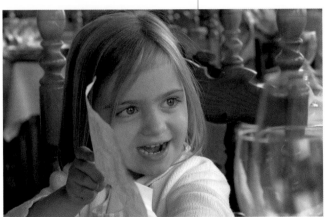

[9-6] Using drawing materials provided by the restaurant, Gloria was concentrating on her art as we waited for the meal. Though there were times when her hair covered her face as she worked, our patience was rewarded when she looked up proudly to display her work to the family.

the waves. Ask them to jump on a trampoline—this is fabulous for getting action. These are all things they do naturally, but you can subtly program the activity for your photographs by asking them to do it for you. Try to start with them facing you, then ask them to demonstrate their prowess. This gives them an incentive to perform for you, yet without sacrificing the spontaneity of the action.

Some children learn games, such as Statues, at school. This game or its regional variations can be played in a park, driveway, or suburban street with several friends or siblings. One person is "it," hiding her eyes as the children advance stealthily forward. When the per-

son cries "Stop" or "Freeze" or "Statues," the advancing children must freeze in position. The sometimes-awkward stances they assume, and the humor and delight on their faces, make terrific pictures.

Animals

If a family has pets and the child is comfortable with animals, the pets can be a source of delightful photographs. The relationship between a child and an animal is one of my favorites to photograph. When handling animals, the tenderness of a child or teenager often comes out most strongly. You glimpse a gentle side of the young person that is often hidden in the daily pressure to be cool.

But not all children are comfortable with animals. I have done commercial photography where I've placed child models in a scene with animals and learned to my dismay that some children are scared of even of a tiny kitten, if they haven't grown up around them. When you try to photograph children with animals, make sure they are used to them and feel at home. Naturally it's best with their own pets.

Babies are a natural inducement to school-age children. A variation on using animals in photographs is to show a child with a younger sibling or an infant. These situations evoke awe and natural tenderness.

Styling

The goal of this book is for you to get wonderful candid photographs, natural and appealing, without the stiffness that comes with making too many adjustments. So how do you balance getting spontaneity when you need to change distracting clothing or jewelry for the photo? You negotiate.

In the photos of Carly in 9-9, you can see the difference between photo A, when she was wearing a headband and jewelry, and the one taken after they'd been removed. When I arrived at their house, her mother rolled her eyes at the outfit and accessories Carly, age four, had chosen for her photo session. Carly's face clouded over when her mother suggested a change. Despite the distractions, I proceeded to photograph her with the adornments she liked. There was nothing wrong with them, except that they created a mild clutter and took your eye away from her sweet face. But don't trample on a child's feelings about the "persona" she chooses to present to you. After I had taken several pictures of her with the headband on, I said, "Good, that was nice, now can we do some without the headband? I'd like to see how your hair looks without it. And maybe the other shirt . . ." At that point, she was delighted to help (noblesse oblige), and I preferred the resulting pictures.

Strategy (When They're Sick of Photos)

What do you do when your children tire of parental photos and greet you and your camera with: "Aw, Mom, not pictures again . . . Give it a break"? You can try, as they request, "giving it a break." Or you can also work out a system to trade photo sessions with someone else.

As you know, there are times when a child will cheerfully do chores at a friend's house that she'd avoid at home. It holds equally true that children may cooperate more if someone

111

A

B

[9-7] In our family, track was a major activity. But all sports and games offer great moments for photography. There are also quiet moments to catch in the middle of a hectic activity, such as when Theo was stretching before running (A). These can be just as effective as the drama of Eddie handing off the baton in a relay (B).

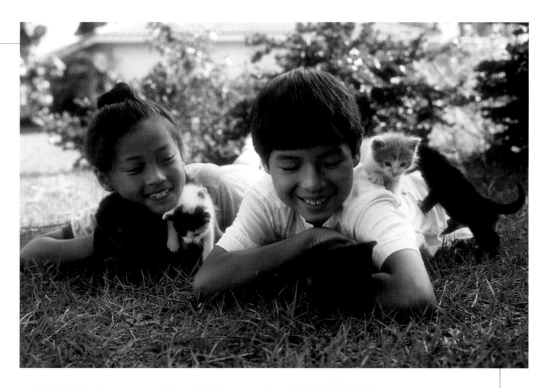

[9-8] Pets can engage a child and offer charming moments for pictures.

outside the family is taking the pictures. It is most often school-age children for whom the novelty wears off and they lose the cooperative spirit.

I've often found that kids will give me respect and cooperation for quite a few days or over several photo sessions because I'm an outsider, a professional, and not a part of their daily life. My photography of them is a new and interesting occurrence. As a result, they don't show me the disdain bred of familiarity that they may show their parents. However, with children in my own family, I've reached the same impasse that almost inevitably happens when children are sick of having your camera in their faces. At that point, I've had to use every wile in the book to get photos—and there were times when I had to back off, sometimes for several months, until the mood passed.

When you reach this barrier, ask a friend who is equally involved in photography of her kids to trade photo sessions with you. If you don't know anyone with equal interest in photography, you can create such a relationship. A good start is with the parent of one of your child's friends. This is always a good plan, since your child will have the inducement of visiting her chum as part of the "price" of the photo session. You can also work with a neighbor or relative, a Cub Scout leader, soccer parent, or drama-club coach. Anyone who has kids he or she wants photographed.

Start early, while your children are young, to build these relationships working with other parents. In addition, you can share the learning process of photography while you help each other.

Joining a photography club or taking photography courses in your area has the dual benefit of improving your skills while making contacts. If you literally keep your eyes open, you will find someone who has kids she wants photographed, someone who wants to learn with you. You can photograph her children and she can photograph yours.

You can also try group sessions, with children from both families together. There is a inevitable chaos inherent in this process, but it can break down barriers among the children and any reluctance they might have to your new photography partner. At this point ask the older kids in either family to help you with photography of the younger ones. They might hold a reflector for you or help distract a young child.

When you introduce the idea of a surrogate photographer, you can explain that Mrs. Jones is practicing her photographic techniques and wants your help. Or, possibly just tell the truth, that you are swapping services. It should work for awhile, at least until the next time they dig their heels in. Most importantly, you won't lose the opportunity to photograph those precious years between eight and fifteen or whenever the reluctance hits your child.

Tips for Photographing All Ages

The techniques mentioned so far in this chapter can be applied to almost all ages. Now we'll take a look at children by age group.

Infants: Newborn to Five Months

Just finding newborns awake with their eyes open is a challenge. For the best photographs, position them slightly upright with pillows or blankets to prop them up. Or if they are lying

down, prop the pillows under the side that is farthest from the camera. Try to avoid making them look like bald, double-chinned old men, which can happen if their head lolls forward onto their chest. Propping them carefully and using the right lens will help. As at every age, you want to feature the eyes.

Avoid wide-angle lenses like 35mm, which can exaggerate the head shape, making it appear like a large egg. (There are sample photos of this distortion later in 11-2). Use a medium focal-length lens, such as 50mm or a 90mm or 105mm portrait lens. Stay on eye level with the infant. Try to have him look at you. He may appear to smile, though it might be only a grimace resulting from a burp or cough. Never mind. Take the picture. The intense stare from a newborn is special.

Also, do some close-ups of fingers and toes. Though it's a hackneyed image, if it's *your* newborn, it's not old. It's miraculously fresh. Go ahead and take that picture.

Photography gets a bit easier in the two- to four-month-old stage. Then you begin to get real expressions and hand movements that show that the baby is responding to you. The techniques at this age are propping the babies up, getting them near the light, and using all the baby talk or rattles you need. Catching them while they are being fed is also worth trying. In spite of the messy face, you can get some adorable gestures.

Infants: Five to Ten Months

Five to ten months is the age from when babies sit up, learn to crawl, and are about to walk. It is a relatively easy time to photograph. They can't motor on their own, so are usually happy sitting up looking at you and being entertained by you. They are usually contained in various ways. In a crib, a playpen, a high chair, a car seat, on a rug—almost anywhere, as you see in 9-10.

While they are contained, you can place them where you have the best light. Move a crib or high chair nearer a window and angle it so they have bright sidelight. Bath time is also wonderful for photos.

Toddlers: One to Two Years

Toddlers between the ages of one and two are at the early walking stage, through the terrible twos. It's in many ways the most challenging time to photograph. They are especially adorable and frustrating at this age. Getting good close-ups in sharp focus takes real perseverance. For close-ups, containment is essential during this mercurial age. As suggested earlier, work with them when they are contained in a car seat, high chair, stroller, walker, or crib.

Give them a book or toy and place them in a big, comfy chair, which provides both a momentary containment and solid background. They may pause in their activity to look at a book, which can provide good close-ups. Just as toy phones always have been, today's cell phones are high priority for toddlers who mimic adult conversations. Paul, in photo 9-11, loves to talk to the cell phone—he also used car keys to make a call when the phone wasn't available.

Finally, forget close-ups for a while. Let them crawl, toddle, climb, run, and practice your action shooting, since what they're keen to do is move.

[9-9] Without offending the child, try to simplify any accessories. Which of these photos is a better portrait of Carly?

A

B

[9-10] Photographer Maria Lyle took this photograph of new-born Katie (A). Notice how she arranged the terry-cloth blankets around her in a little cocoon. The slight shadows formed by the blankets give texture and frame the infant. Without them, the entire picture would be too pale and washed out. Then Maria took the time to wait for a look, that gaze from a newborn which alternately appears to say "What have I gotten myself into," or "Who are you and why do I care?" Watch carefully for when your four-month-old responds with both face and body language like in photo B. © Maria A. H. Lyle

[9-11] Toddlers like Paul are keen to do things they see around them, including holding emotive conversations on the phone. Use whatever works to keep a toddler contained and distracted.

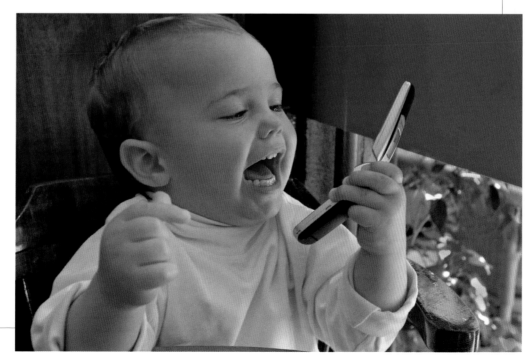

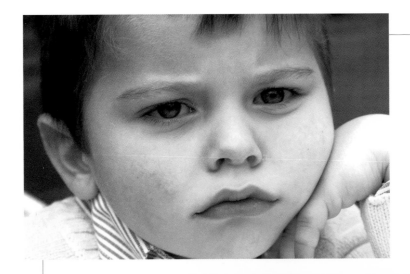

[9-12] Conversation is a good way to cajole your subject into a bettor humor and improve the expressions in your photographs. Marc went from cranky to happy in a few moments of talk.

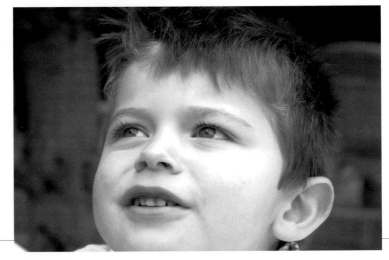

Preschool: Three to Five Years

With children three to five years old, talking or creating a conversation works the best. Children communicate like mad. They sometimes seem drunk with the power of words, chattering away incessantly. Harness that energy and get them to talk to you.

Also, you can use conversation to create a mood swing if you aren't getting the cooperation you want. In the sequence of Marc in 9-12, he started out grouchy. He was in a snit because his mother had admonished him for not behaving nicely for the photographs. At that stage, the best approach is to send mom away with the other kids. We started a conversation that provoked a look from him of cautious interest. I asked if he had seen the bird that just flew to the birdbath. At that point he began to look in earnest for the bird, finally describing what he saw, and ending with a pleased expression.

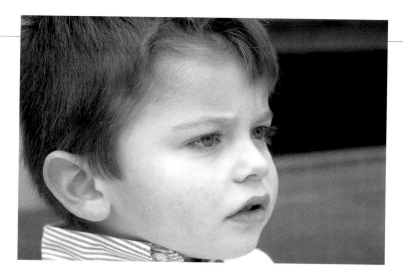

Early School: Six to Eight Years

The years between six and eight are good for photography because school has taught children discipline and they can follow directions. If you ask them to face the light they will. But this cooperative spirit can result in canned expressions, pleasant but stiff. This age responds well to being silly. If they force a smile for you, inevitably a staged one, you can be playful to break the stiffness. Try saying: "Don't smile. No really, don't smile for a minute. Rest your face. No. Stop it. Come on, I said *don't* smile!" A few moments of that type of foolish conversation will usually result in suppressed giggles, bursting into a guffaw and providing an exaggerated expression, which will calm down shortly into a pleasant, lively, half smile retaining a sparkle in the eyes. It also works to tell them it's time to make goofy faces. Give them five minutes, or take ten to twenty pictures, while you

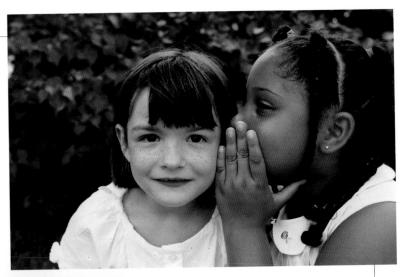

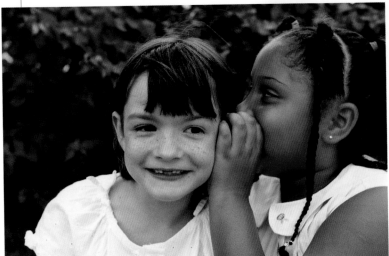

[9-13] See how Mary's expressions progress as her best friend Emily elaborates on the secret? The child who is listening is most clearly seen, so you take turns with each child being the teller and listener. That way each family will have a good photograph of their child.

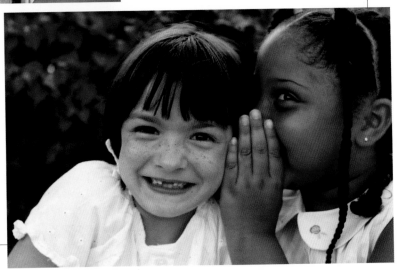

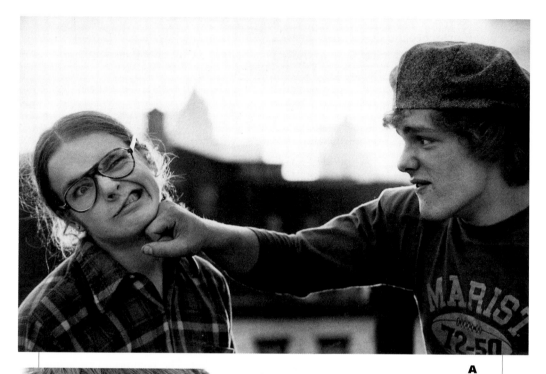

A

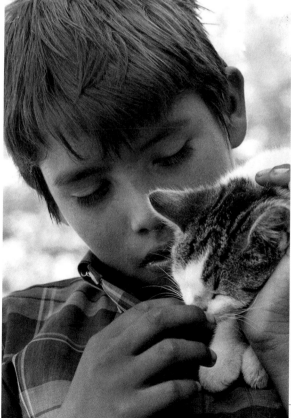

B

[9-14] Brothers Paul and Keith got along very well, but some discussion of a recent movie got them into this mock fight (A). Years later they love this picture, as does the rest of the family.

Using a ploy is sometimes necessary with teenagers. "If you'll just keep it there a few minutes I can get a good shot of the kitten" isn't truly devious, but you really do want the photo of the child much more than the kitten (B).

photograph them making grotesque grimaces. Mothers cringe but the kids love it. It's only fair to let them play, and it has the additional benefit of loosening them up. Right after they relax from the silly faces you can get a lovely, residual gleam.

Whispering, telling secrets, seems to have its own magic. It works like a charm to loosen up children in this age group, especially between friends. If you want to program the scene, take each child aside and ask her what type of secret she could tell to the other.

Talking normally and seriously will also work with this age. If you have been doing photography of the child for a number of years, the conversation may be nothing more than "I want to get some pictures to send Aunt Ethel. Let's go over here and talk a bit while I try some photography." That's a straightforward approach that works best with school-age kids, even teens. You aren't going to fool them into thinking you really want to hear about the school play while you have the camera to your eye. This is the moment for honesty. "I want to take some pictures and meanwhile, while we are doing it, tell me about the school play. Have they finished the auditions?"

Later School: Nine to Twelve Years

You have to be direct and use a no-nonsense approach with nine to twelve year olds. No sly tricks will fool them. But there is usually a faux maturity you can tap into. Use friends. Borrow your child's best friend and take their pictures together. The techniques of being silly will work, if you make the process a little more sophisticated. Don't forget games and sports. They become quite accomplished at this age.

Teenagers: Thirteen to Eighteen Years

Good luck! Photographing teens is difficult, since many of them are self-conscious to an extreme. With teens, sports and active pursuits are always available to you. But the quiet moments and close-ups may be the most difficult to get from this age.

First, avoid trying to take photographs in front of anyone else. Complete privacy is very helpful if you want to do face shots. That removes any conflict between their desire help you and the impulse to impress onlookers with an assumed indifference, an attempt to stay cool.

Conversation is essential to put this age at ease. Choose a part of their world that totally absorbs them. You might disarm them by talking about their sports, music, or other activities. If you are the parent this will be easier.

Unless you can't tolerate deviousness, tell them you are experimenting with a new camera, a new hobby, a new type of film. Explain that they can be still while you adjust the focus. Anything. Get them to ham, let them know they can horse around, be goofy. Also, enlist their friends, if they are open to the idea, to add to the hamming. You'll get silly pictures, but a few will be deeply appealing, and a refreshing moment in your teenager's life. Or let them be pensive if that suits the moment.

Group Shots

The most difficult venture is to get a group of children of different ages to give you nice expressions at the same time. You might want to photograph several siblings of different ages

in one shot, or an even larger group—for example, cousins at a family reunion. The difficulty will be to keep the attention of all of them at the same time, since different ages don't always respond to the same stimulus.

One trick to get smiles from a group, you may remember from chapter 4, is what I call the hair-pulling ploy that works well with young kids. I discovered another gimmick, during a professional job, when I was photographing a group of about thirty schoolchildren.

We needed a full-page photo of children from ages six through twelve for the back cover of a series of books. They were neatly arranged on a set of bleachers in the gym and ready to look *happy*. But, whatever we did, only some of the kids were amused, usually just the younger ones, as the older kids sat in cool self-possession. The editor of the project did everything she could to break the ice—played music, even told jokes. Finally she pulled a misbehaving six year old from the group and started dancing with him. Then on a signal, she took him and turned him upside down. That did it, getting guffaws from every age and several great shots of the spontaneous outburst. You may not need to go to that extreme, but you will use your ingenuity to loosen up a group.

Payback

During the course of trying the approaches in this chapter, new ideas will come to you. You will develop your own techniques for continuing to get good photographs of the children who are most special to you at every stage of their development.

Just keep in mind that as much as having the photos may please the child in later years, right now the incentive for taking pictures is probably quite one-sided. Make sure the children get some benefit, some payback now for helping you. Exploitation happens when they aren't getting any fun out of it. Occasionally allow them some equal time to ham it up, to be silly, and do whatever pleases them, even if it's not what you had in mind for the pictures.

Later in the process, letting them help you choose the best photos to frame or put in an album will keep them involved and shows you value their opinion. Ask them to select which photos to send to relatives. Ask older children to help choose which pictures are best of the younger siblings.

An obsession with getting wonderful photographs can become intrusive if it's not leavened with respect for the children being photographed. No group of wonderful pictures is worth the sacrifice of your relationship with a child if it becomes merely a greedy quest for more and better images. I have had to plead guilty to that charge upon more than one occasion.

On a recent visit with close family friends, the four-year-old I had been photographing asked when she would have photos to show her friends at school. I wasn't planning to do any printing until my return home several weeks later. She repeated the request in plaintive terms. My solution was to go to a local photo store and buy a disposable camera. That evening I took a lot of snapshots, letting her do the same—she photographed everyone in the family. She was delighted when the prints were ready the next day.

The joy of photography with your children will be enhanced if you keep their needs as part of the process.

Choosing Black and White or Color

Since the advent of color photography, there has been an ongoing debate about the relative aesthetic merits of black-and-white photography versus color.

It was held by many that serious photography was done in black and white because black-and-white photography required strong composition, evocative expressions, and subtle lighting to create a fine photograph. Black and white gained a reputation for being a purer form of photography, which didn't depend on what was considered the cheap, easy appeal of color. It was argued by these purists that color could mask inferior or mediocre composition by the sheer attraction of the color.

There is no doubt that a great black-and white-photograph has an indefinable quality that is very appealing. However, as the use of color matured, many of the world's finest photographers brought color images to the same high level of quality that had been known in black and white. Brilliant color photographs have taken their respected place in museums, galleries, and the minds of the public.

The argument has become moot. Now, it's a matter of personal taste whether you prefer color or black-and-white photography. And that can change from day to day according to your mood, the light, or the subject.

Friends often ask me to take black and white when I am photographing their children. "I just love the black and whites you get of the kids," many have said. They forget that, with a little more attention to lighting, they could get similar interesting black-and-white results themselves.

I confess to a life-long love of black and white, but not one that in any way negates the beauty of a fine color photograph. Either can be the medium for a truly strong portrait.

A

D

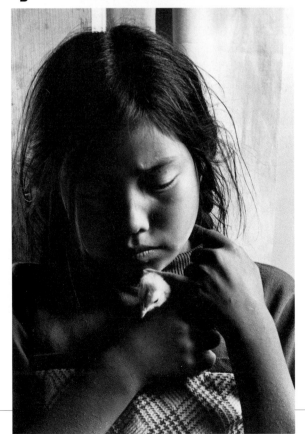

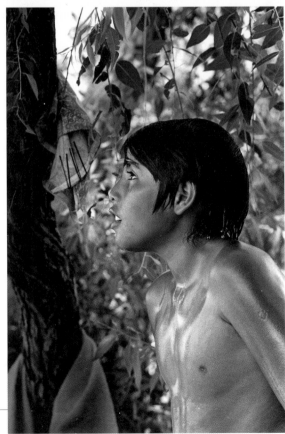

B

[10-1] This photo of Mary Jane catching a hen (A) works in black and white because the light from the open roof highlights her hair and face. In color, your eye might have been drawn to the rusty fencing and other distracting color fragments in the background of the chicken house. But in black and white, the wooden slats and rusty fencing become merely a series of neutral gray tones creating a nice background for a girl in glowing light. Tim poised to dive into the water (B) is another photograph that is successful in black and white. The light on his wet skin seems to lend a universal quality, making him almost a symbol of "boy in nature." The black and white goes beyond what would be, in color, just a snapshot of a boy at a swimming hole. Tessa at the doorway of her house (C) was being tolerant of my photography with the gentle disdain of a teenager. The direct, not unkind, gaze and crossed arms are emblematic of her emerging independence. I wasn't about to move her or ask for variations. I decided on black and white because, though the light wasn't great and even a bit flat, there were interesting shapes and lines in the photograph. In color, her sweater—white, beige, and brown—would have been just blah. In black and white, the horizontal lines in her sweater, in the screen door, and on the siding all make a frame for that pair of eyes confronting us and the world. Finally, Edith with a baby chick (D) is a stark version of black-and-white style. In the almost-silhouette photograph, one half of her face is lost in shadow. But the light gives just enough detail to see her concentration and tenderness.

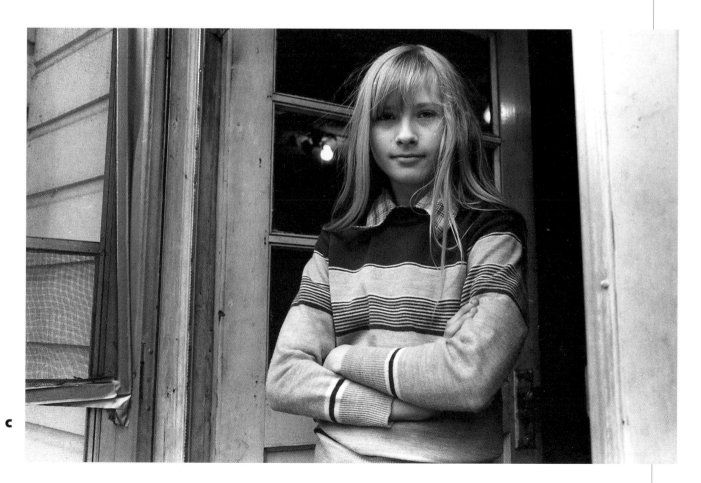

C

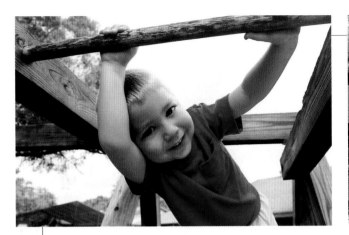
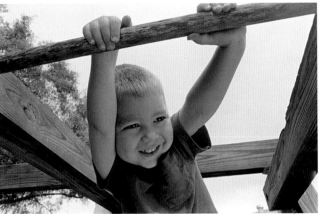

[10-2] These two photos of Sam were taken using film and at the same time of day. The light is fine, well modeled, and would work well for either black and white or color. But to me, this subject calls for color. Color works better because of the warmth in his brown eyes, and of course the red shirt adds some life.

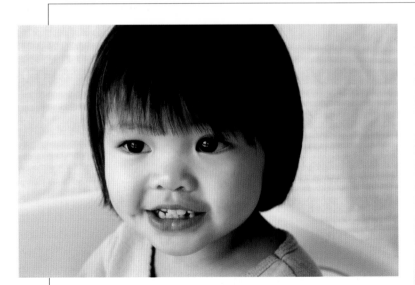
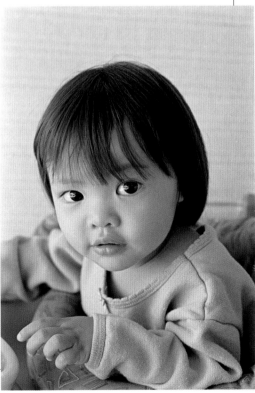

[10-3] Erin looks lovely in either black and white or color. The directional light gives good, soft modeling to her face. To me, they are equally successful. It's a toss-up. What's your vote?

Digital Conversions from Color

The following groupings of photos show digital color that was converted to black and white. You'll see that some images convert more successfully than others.

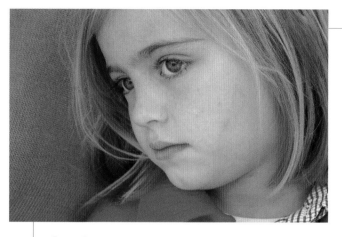

[10-4] Here is an example of a conversion from color to black and white that does not work well. This photo is better in color. It was taken in late afternoon in a very flat light. You'll notice that the skin tone is even, without any shading or modeling, so Gloria looks almost two-dimensional. But the flat tone doesn't detract from the color version of the picture. Her blue-green eyes dominate the photo, and the red jacket against the tawny tones of her hair and background (her dad's sweater) all add some life to the picture. But the light is so flat that once the color is gone, there is a dull and listless look to the black-and-white conversion. Those of you who work with digital-imaging programs know that the contrast in the black-and-white version can be heightened to add a bit of drama, but it's no substitute for the sparkle and sculpted feeling of a well-lit black-and-white photo.

[10-5] In these two versions of the same photo of Jess, I find the black and white more effective. The original was a digital color photo that was converted to black and white. The color is adequate, but the black and white has a subtle look that seems to suit her mood. Somehow, the soft halo of her backlighted hair, the pensive expression, and the soft gesture of her hands have greater power in black and white. The cheery color of her pink gingham seems to pull against the serious moment.

129

When to Shoot Black and White

Certain moods, light, or locations may call for black and white instead of color. If you don't have a strong partiality to either color or black and white, you might consider doing some experiments to develop your taste and see where your inclination lies.

This discussion isn't intended to complicate the process of taking your child's photograph, add confusion, or add yet another layer of decision. However, for those of you who have mastered lighting and the use of lenses, you may want to try some of the subtleties of working in black and white.

It can become simply another choice, often an intuitive one, you make when deciding on a photograph. The sample photos in this chapter capture something specific about the child. Some days I wasn't sure whether to use color or black and white in a given type of light, and I had to try several before I was sure. With other sequences, I was aiming for a particular mood, and black and white suited it perfectly.

Ways to Get Black and White

Traditional film cameras, as well as digital cameras, can provide black and white images.

Film

Using a film camera, you can get splendid black-and-white photographic prints from many of the various black-and-white films on the market. Though there are ways you can convert a color slide or a color print to black and white, it's not advisable due to the loss of quality in the conversion process.

Digital: Having It Both Ways

Hey, hold your horses, you may say. I don't have to make that decision if I shoot with a digital camera, right? I can just shoot in color, then convert to black and white later, if I want. That's true in a technical sense. You can change any color image to black and white in the computer. Using imaging programs such as Photoshop®, you can convert a color image to black and white quite easily.

But, you may want to consider using the other option, which is to shoot digital directly in black-and-white mode. On many digital cameras there is a black-and-white setting. Using this setting gives the maximum quality in black and white, in some cases better than a conversion from color. But the die is cast—if you decide to shoot digital black and white, you can never turn the images into color.

But whether shooting film or digital, I advise you to start thinking in black and white to get the most out of it. Think about your choice as you start the shoot, to see which suits the light and the mood of that day's photography. You'll find that you may design a photo differently in black and white than in color, depending on the light available, the colors on the child, and the background.

Situations That Call for Black and White

There are locations and scenes that seem to be natural for black and white. The photos in this chapter show a range of lighting situations that suit rendering the subjects in black and white.

There is no limit to where you can go with your portraits, whether in color or black and white. So don't tie your own hands in terms of the aesthetic range open to you.

Lighting in Black and White

The quality of light that works best in black and white can be seen in the sample photos in this chapter. Black-and-white photography benefits from a strong light, often found in bright open shade, which gives a modeled, three-dimensional look to the subject. It is often called directional lighting—that is, light coming from one direction, usually the side, as opposed to a flat, even light. A photograph taken in flat light can be salvaged by color in some cases. But for black and white, it helps to have a light that gives a sculpted, rounded quality to the subject. As you go through this book, study the black-and-white photos to become aware of the subtle gradations of gray, which can be so pleasing.

In the end, taste is the factor that will influence you in choosing black and white or color for your photographs. Just keep black and white in mind as a way to add simplicity and elegance to your portraits.

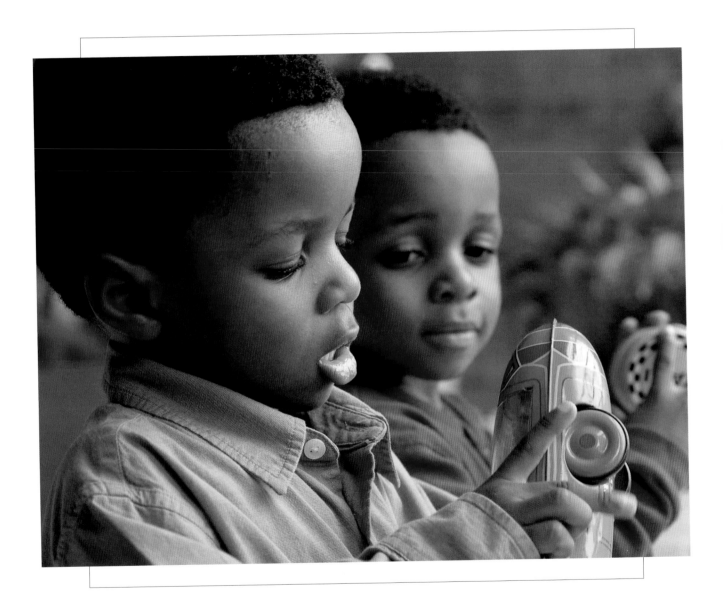

The Technical Side of Photography

Understanding the technical aspects of the photographic process will help you improve your portraits of babies and children. If you are already a skilled technician, or if you are the other extreme—someone for whom the technical side of photography doesn't have any appeal—then ignore this chapter. Just continue with the camera system you have. If you follow the advice in the earlier chapters in this book about taking close-up photographs, finding good lighting, and watching for clean backgrounds, you should find significant improvement in your photographs. If you are getting satisfactory results, then you may not need to understand how and why the camera does its job.

However if you have any frustration about the technical quality of your photographs—they are often too light or dark, they aren't sharp, they look blurry—it may be equipment limitations that are curtailing your achievement.

Assess Your Equipment

See where you stand. It's a good idea to test your current equipment to find out its capabilities and limitations. That will help you decide if the equipment you have is up to the job or if you want to make a change. One of the more important things to check is focus ability. Test your close-up focus. Set up an object that doesn't move, such as a teddy bear, doll, or potted plant. Place it in good light. Calculate your distance from camera to subject using a ruler or tape measure. Whether you are using auto focus or manual (or even using the distance scale on the lens) you will learn the same information—how close you can work and still get good sharp pictures.

Upgrading Your Equipment

If you do plan to upgrade, there are simple ways to accomplish it without making a huge headache out of the process. Before shopping for a new camera system, make a few decisions:

- ▶ Do you want a film or digital camera?
- ▶ What is your price range?
- ▶ What features do you want or need? Put another way: what's giving you trouble with your present camera?
- ▶ What is your photography level: amateur, intermediate, advanced?
- ▶ Consider the kind of photos of babies and children you want to take. Is it mostly portraits (faces)? Or do you want to photograph action, like sports? That will affect the lenses you need.

But we'd better not put the cart before the horse. If you are still in a quandary about what you need, you may want to know a bit more about photography to do the research and make decisions about camera equipment. However, if you are ready to buy, then skip to the end of this chapter for guidance on how to research and buy new equipment.

Fundamentals of Photography

For an overview of photography, let's look first at the equipment and how it works. Then we'll examine how the working of each piece of equipment affects the appearance of your photographs—the aesthetic influence. Finally, we'll come to the differences between film and digital photography. That discussion will come at the end of the chapter, because in most ways, the principles of photography are the same, whether you use a film camera or a digital one.

Photography is the process of light recording an image on a surface. For decades that surface has been film, a plastic sheet with a light-sensitive chemical coating. In digital cameras, that surface is an electronic light-sensing chip. Once the chip has recorded an image, it is stored on a memory card in the camera. The image information—whether on film or on a memory card—can be transformed into a physical object—a print or transparency. When the transparency is a mounted piece of 35mm film, it's called a slide.

There are a number of overlapping terms and concepts to explain how you create a photograph. To get a technically good photograph, you are concerned with exposure, focus, and stopping the action. This trio is in turn controlled or affected by aperture, shutter speed, lens focal length, and film speed. Each of these will be examined in detail, so don't get discouraged. As my friend, photographer Maria Lyle, tells her students, photography is very much like a puzzle. Once you put all the pieces together, the process becomes clear and frees you to have fun.

We will be examining the following parts of the camera:

- ▶ *Body:* The equipment as a whole
- ▶ *Lenses:* The glass pieces that allow light to enter the camera
- ▶ *Aperture:* Adjusts the openings on the lens to allow different amounts of light in
- ▶ *Shutter:* Opens and closes the aperture—the speed of the shutter indicates how long the shutter stays open, allowing light into the camera

This is the equipment that allows you to adjust the exposure, focus, and stop action in your photos. These are the pieces that will build the puzzle.

Cameras

The camera body is a light-tight box that holds the film or digital sensor. Light reaches the surface of the film or sensor, recording the image, through an opening in a lens attached to the body.

Camera bodies come in various sizes, named by the size of the film they hold. The most common is the 35mm camera, which holds film that is 35 millimeters wide, and produces an image of 24mm × 36mm (or 1" × 1.5"). The next group is called medium-format cameras, and although there are several types, the most common uses film that produces an image of 2.25" × 2.25". The medium-format cameras, including the famous Hasselblad camera system, are used most often by professional photographers and advanced amateurs.

Finally, there are the professional-level large-format cameras, which use 4" × 5", 5" × 7", or 8" × 10" pieces of film. (These large-format cameras are also available with attachments, called digital backs, for use in digital photography.) These cameras are used mostly in high-end studio work or for serious landscape photography—desirable because the larger the film, the greater the detail and the larger the print that can be made.

The earliest cameras were large-format ones that used awkward glass-plate negatives. A camera using 35mm film was an innovation of the 1920s, which made photography less cumbersome and opened the field to many more people. Leica was the flagship camera of the era. The new, smaller cameras paved the way for the spontaneous, candid style of photojournalists and documentary photographers from that period forward.

Camera bodies and lenses have a variety of adjustments that control most aspects of the photographic process, which we will review in detail. Primary among them are adjustments that control the aperture, or size of the lens opening (f-stop), and shutter speed, or the time for which the shutter stays open. The aperture can be controlled on the lens or, with some cameras, on the camera body itself. There are also other adjustments—for film speed, auto focus, auto exposure, programmed photography, and flash. All these adjustments increase with the complexity and sophistication (and price) of the camera. We'll look into these in more detail below.

Single-Lens Reflex (SLR)

The vast majority of camera bodies are single-lens reflex cameras. This simply means that with an SLR, you see through the viewfinder what you are getting on film. Other types of camera bodies, such as rangefinder or double-lens reflex cameras, show only approximately what will appear on the film. You are not viewing through the lens that will take the picture. The latter are specialty cameras, used primarily by professionals and very advanced amateurs.

Lenses

The lens, a piece of high-quality optical glass, is attached to the camera body and used to focus the light coming into the camera and onto the film or the digital sensor. Though it's useful to

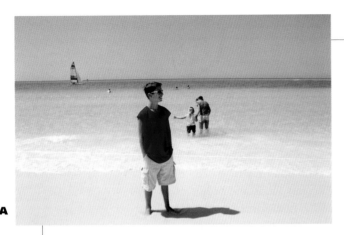

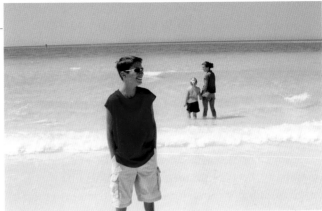

A

B

C

D

[11-1] These photos of Colin were taken from the same spot with different lenses. In photo A, I used a 24mm wide-angle lens. The picture is very sharp throughout. Even the sailboat on the horizon is in focus. I took photo B with a 35mm lens, also a wide-angle lens; it gives a closer view but maintains good sharpness. You can see that Colin's sister, Caitlin, has detail in her hair and profile. In photo C, a 50mm lens brings us closer still, and the girls are now soft and blurry around the edges, as is the new sailboat that came into view. Finally, the 135mm telephoto lens brings us very close to Colin in photo D. His sister is blurred, completely out of focus, and the detail in the water is gone.

understand the technical descriptions of lenses, it's more interesting to know the effect a particular lens will have on the appearance of your photograph. Each lens is designed with a specific focal length, which, as you'll see below, gives a distinct look to your pictures.

Focal Length

The focal length is the magnifying power of the lens and is given in millimeters. Focal length, in turn, determines the angle of view. A lens with a short focal length has a wide angle of view, and vice versa. Thus, lens focal length sets the limits of how wide or narrow your angle of view will be in a photo. If this seems puzzling, then perhaps you haven't worked with different lenses to see firsthand the difference that the focal length of a lens can make in your pictures.

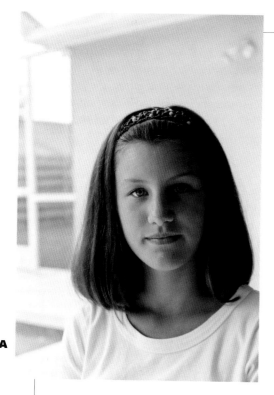

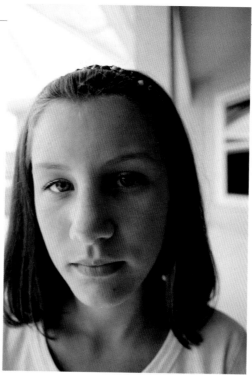

A

B

[11-2] A 90mm lens was used in photo A to show Caitlin's lovely face with its well-balanced features. But, in photo B, the 28mm lens creates an unattractive distortion. Whatever is closest to the camera appears larger, so her nose is exaggeratedly large and her chin all but disappears. Photographers often use this exaggerated perspective to artistic effect, but it's not flattering.

Some basic cameras are made with a fixed focal-length lens, and that gives you only one angle of view. To understand focal length, you may want to look through different lenses on a camera to see the difference in angles of view. Any camera store can help you.

Generally, the focal lengths of lenses are sorted into three groups: wide-angle lenses (15–35mm); normal, or mid-range, lenses (50–70mm); and telephoto lenses (80mm and up). Telephoto lenses are called long lenses in photography jargon for two reasons: first, they are literally longer in measurement (and a lot heavier) than normal or wide-angle lenses; and second, they allow you to photograph a far-way object and still get an image on film that is large enough to be useful.

To imagine the difference in focal length, try putting your hands up near your eyes to the sides of your temple, as if your hands were blinders on a horse. This corresponds roughly to the view of lenses in the 50–70mm range. Next spread your hands a bit wider, each to about a 45-degree angle from your face, so you include the periphery of your vision. This is what a wide-angle lens will include in your photo. Now, make a circle with your hands directly in front of your eyes. The small area of view that is seen through the tunnel of your hands approximates what you will see through a telephoto lens.

In addition to governing the angle of view, focal length will also affect how sharp or blurry the foreground and background of your photograph will appear. At the same aperture (f-stop), a wide-angle lens will have greater areas of sharpness from the front to the back of a photo than will a telephoto lens. Telephoto lenses will have a much shorter area of sharp focus. Naturally, the normal or mid-range lenses are in the middle.

The distinct appearance created by each lens is illustrated in the photos of Colin at the beach. Each lens makes the scene look and feel very different. Colin stayed in the same spot throughout these photos, as did his sister and cousin in the background. I also remained in the same place on the shoreline. The only change from one photograph to the next was in the focal length of the lens used. The world of lenses is one of the most exciting aspects of photography. What can be done through your choice of lenses is the heart of the aesthetic impact of lenses and why it's worth understanding them.

Wide-Angle Warning

Though a wide-angle lens can be used for creative and interesting photographs, it is dangerous (aesthetically) to use for portraits, because if you work close up, it can cause faces to look distorted due to exaggerated perspective, as seen in 11-2.

There is a wide range of lenses available for most cameras. You can find them on the Web sites for major camera manufacturers such as Nikon or Canon. There are a number of specialty lenses, such as those for architecture or underwater use. The close-up lens deserves special attention for its usefulness in photographing babies and children.

Close-Up Lenses

A close-up lens is also called a macro lens or a micro lens. There is discussion of close-up lenses in chapters 2 and 6. Often, the word "macro" or "micro" will appear in the lens's name, such as the Nikkor 60mm f/2.8 Micro, or the Canon 50mm f/2.5 Macro. A close-up feature is included in some zoom lenses and on some digital cameras.

Technical information aside, the key distinction is that a close-up lens allows you to take a photograph very near the subject and still have sharp focus. With close-up lenses you can photograph as close as two inches from your subject. That's close. Close-up lenses are used in photography for everything from scientific and technical studies to dramatic close-ups of flowers or textures in nature. I like close-up lenses for the extraordinary intimacy they bring to a photograph of a baby. (For an example of a child photographed with a close-up lens, look at the chapter opener photo for chapter 2.)

Learning about Lenses

For those who intend to delve deeply into equipment research, your choice at this stage is between a deeper involvement in learning photography, or an effort to stay as simple as possible while taking good pictures. (As you'll see later, the simple way is to have one good zoom lens.)

▶ *Attached Lens:* The attached lens, as its name suggests, cannot be removed and is most often found in entry-level or lower-priced cameras.
▶ *Interchangeable Lenses:* Cameras that offer the ability to remove and replace a lens are called interchangeable-lens cameras. Generally, more advanced cameras will have interchangeable lenses, though in the newer generations of digital cameras some very good cameras have a zoom lens without the capacity to interchange.

A

B

C

[11-3] Make sure when using auto focus that the auto-focus area, visible in the center of your camera's viewfinder, falls on the part of the picture you want in sharp focus. In photo A of sisters Jessie and Jaymie, the auto-focus area was centered between them. Since it fell on the gazebo in the background, that is where the lens focused—making that area sharp while the girls were blurry and out of focus. The solution is first to focus by placing the auto-focus area over either of the subjects, as in photo B, let the lens focus, then hold the focus-lock button while moving back to frame the photo you want. Then wait for the good expressions and shoot (C).

▶ *Zoom Lens:* A zoom lens has the ability to vary the focal length, so that you can go from one focal length to another without switching lenses. Some popular zoom lenses are ones that go from 28mm to 105mm, or from 80mm to 200mm. A zoom lens conveniently provides variety in the focal length without the bother of switching lenses and carrying extra heavy equipment. A zoom lens can be a lens attached permanently to the camera, as in the case of a point-and-shoot, or it can be interchangeable, as with a zoom lens for a 35mm SLR.

▶ *Fixed Lens:* A fixed lens has only one focal length. It can be an interchangeable lens or one that is permanently attached to the camera.

Aperture

Lenses are built with openings that can be adjusted to allow more or less light through the lens onto the film or sensor. This opening is called the aperture and the size of the opening called the f-stop.

The aperture affects two important elements of photography. The first is *exposure*—how light or dark your photos are. The second is *depth of field*—how much of the scene, from front to back, is in focus. You'll see later that aperture works with shutter speed and film speed to complete the exposure trio.

[11-4] In this restaurant scene, the glass on the table at right in the foreground is out of focus, as are the chairs behind Gloria. Only her face is in sharp focus. It makes a very nice effect, actually using the clutter, softened by being out of focus, to frame the child. It also happened to be my only choice. Since there was very little light, I had to use a wide aperture of f/4. I knew that would mean low depth of field, so I was careful to focus on her eyes.

Focus

The lens enables you to focus, or make your pictures sharp, by means of turning the lens's focusing adjustment until the area of interest, usually the face, appears sharp and clear. Many lenses do this automatically; other lenses have the ability to allow manual focus.

Auto focus is very handy and can be a great tool. But you must *tell* the lens where you want it to focus. You must make sure that the auto-focus area, usually in the center viewfinder—which is where the lens assumes you want the focus—is placed over the area you *do* want in focus. Otherwise your subject may not be sharp. If you have two children centered in a photo you may find that the auto-focus area falls between the children, which brings the background into sharp focus but leaves your subjects blurry.

The way around that problem is to use your camera's focus-lock feature, if available. In some cameras, depressing the shutter button about halfway down will lock the focus. Your camera may also have a focus-lock button, which does the same thing. Just prior to taking the photo, place the auto-focus area in the viewfinder over one of the two children, and immediately press the shutter or focus-lock button (depending on what your camera uses), which keeps the focus on that spot. Of course, his technique works best when both subjects are the same distance from the camera, that is, next to each other, as in photo 11-3. There is a chance that instead of locking the focus you may press hard enough to actually take the photo without the intention of doing so. This is just a matter of learning the feel of your own camera's focusing system.

Once you have locked the focus, move the camera back to framing both children and shoot the photo. It takes some practice to become skilled at auto focus with fast-moving subjects. There are some exceptionally advanced auto-focusing systems that continue focusing as your eye or camera follows the movement of the subject, but these features come only in more expensive cameras.

How Much of the Photo Will Be in Focus—and Why?

We saw in the photos of Colin at the beach that the focal length of the lens determines the extent of the sharp focus in a scene. Wide-angle lenses give greater areas of sharpness, front

to back, in a picture, and telephoto lenses less so. There is another wrinkle to it. In addition to the focal length of the lens, the degree of focus is affected by the aperture (opening) of the lens. The smaller the aperture, the greater the area of sharp focus; and the larger the opening, the less the area of sharpness, as you'll see, with the explanation of depth of field.

Depth of Field

How much of the scene, from front to back, will be sharp is called depth of field. Depth of field is often defined as the zone of sharpness that extends in front of where you focus (on your subject) and in back of it. You can also think of it as the sharpness of the foreground and the background.

Depth of field is controlled by three things: lens aperture, lens focal length, and camera-to-subject distance. The simple rule is that the smaller the aperture (higher number f-stop), the greater the area, front to back, that will be sharp. The larger the aperture (lower number f-stop), the smaller the area of sharpness. Because aperture is one of the things that controls exposure (shutter speed is the other), getting maximum depth of field is not always possible in low-light situations, especially with a moving subject.

You'll see the results in your photos regardless of your knowledge of depth of field. But understanding depth of field allows you to control sharpness in a creative way to design your photographs and enhance your portraits.

How Do You Choose the Aperture?

If it is a bright day with lots of light, you can use a smaller aperture (f/11, f/16, or f/22). If it is late in the day, cloudy weather with very little light, or an interior with scant window light, you will choose a wider aperture, such as f/5.6, f/4, or f/2.8. Just remember that you open up the aperture to let in more light, or close down the aperture when there is a lot of light. The confusing thing about f-stops is the bigger numbers mean smaller apertures, and vice versa. Just remember that the *wider* opening has the *smaller* number, but the *smaller* opening has the *larger* number.

What Causes Depth of Field

The technical folks who design lenses tell us that the center of the lens has the greater sharpness, and that as you come to the edge of the lens, the sharpness falls off. So, if you close down the aperture to a small opening, you are using the sharpest part of the lens. Conversely, if you open up the aperture, you are using the entire lens, including the edge, which provides less sharpness.

Photographers talk about this difference as having a *good* depth of field when shooting at an aperture of f/22 or *shallow* depth of field when shooting an aperture of f/2.8. "Shallow" depth of field means that very little of the photo will be in focus. You might focus on one part of a subject, and the space a few inches behind or in front of it will be out of focus. You might see this in your close-up photos taken in low light. It can happen that the depth of field is so shallow that one eye, the eye nearest the camera, is sharp, but the nose and left eye, being farther from camera, are in soft focus, or blurry.

141

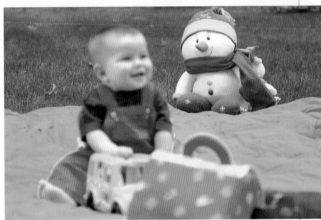

A

B

C

[11-5] The toys around baby Ryan are too distracting to make a nice picture of him, but they serve a purpose. We placed the toys in front and in back of him to illustrate the depth of field rule: The smaller the aperture (higher number f-stop), the greater the area, front to back, that will be sharp; the larger the aperture (lower number f-stop), the smaller the area of sharpness. When comparing the focus in these pictures, check three objects in each photo. First, look at the red satchel in the foreground, next the baby in the center, and finally the snowman toy in the back. Check the sharpness of each element in each photo by trying to see the detail in the object. The same lens, 50mm, was used for all photos. The significant difference in each photo was the aperture. (Of course, when we changed aperture it was necessary to adjust shutter speed to get the correct exposure.) But the effect on the appearance of the photo was from the aperture. In photo A, the aperture was small (f/13). In this photo, the baby is in sharp focus and the toys in front or back are almost sharp. There is relatively little loss of sharpness from the front to the back of the scene. (Take a look at the design on the red bag and on the eyes of the snowman toy in back.) That aperture gives us plenty of depth of field. In photo B, the aperture was large (f/2.8). The large aperture gave a much shorter area of focus from front to back. We focused on the baby, so he is sharp, but the toys in front and back are not sharp. (Again, check the red bag, which is now blurry and the design harder to see, plus the snowman's eyes are soft.) This illustrates "shallow" depth of field. The point is even more clearly made in photo C, where we focused on the snowman way in back. The baby and the front toys are completely out of focus and appear blurry—the only sharp element is the snowman. (For those who want the exposure details: photo A was exposed at f/13 with a shutter speed of 1/60th of a second. Photos B and C were exposed at f/2.8 with a shutter speed of 1/500th of a second.)

For an example, look back in chapter 3 to the photo of Grant in 3-8A where the eye farthest from the camera is not in sharp focus. I don't find it bothersome. But if you don't like this look, then have the child face toward you. Facing forward to the camera, both eyes will be on the same plane, and both eyes will be sharp. A lens that has a very wide maximum aperture, for example f/2.8, f/2.0, or f/1.4, is called a "fast" lens. This is especially important when selecting a telephoto lens, because the longer focal length magnifies the effect of camera shake, and thus requires a fast shutter speed (and hence a wide aperture) when you are handholding the camera.

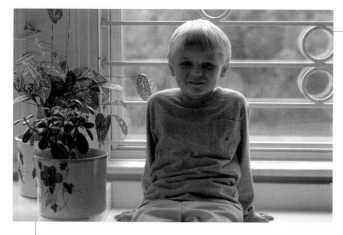

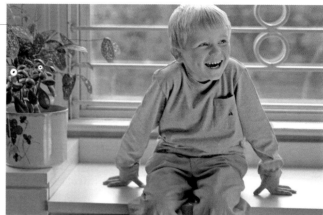

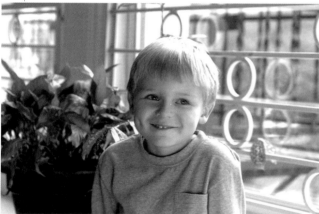

[11-6] Window light can fool a light meter. If the meter measures the light from the window, and you use one of the automatic settings on your camera, your subject may be too dark while the window is properly exposed. Measure the light on your subject, press the exposure-lock button on your camera, and then compose your photo and shoot. Another solution is to angle your subject so the window isn't dead center. Flash isn't a good option in this situation. It can create a reflection in the window and destroys the gentle quality of the natural light.

Exposure

Exposure is simply getting the right amount of light in the picture. The technical goal is to have the photograph accurate in appearance—not too light or too dark, but faithful to the scene with a correct appearance in terms of brightness.

Of course, accurate exposure is really in the eye of the beholder. Individual taste will account for preferences for darker or lighter images. A darker tonality is considered by some to give a richer, more saturated, and pleasing color. At other times a lighter-than-normal tonality, called high key, is the sought-after aesthetic effect. Good exposure can be subjective.

Getting Correct Exposure

The yin and yang of exposure are the aperture (f-stop) and the shutter speed. Put another way, exposure is a give and take relationship. If you add light via the aperture, you need to take away light through the shutter speed, and vice versa.

Take that thought again. If you *add* light via the aperture (by using a larger opening/ smaller f-stop), you need to *take away* light by choosing a faster shutter speed, so that the shutter stays open for a shorter time, letting in less light. If your camera is fully automatic, you may not have to bother about this relationship, but understanding the workings of

exposure may help explain some of the results you get. You'll see how they work together to control the amount of light.

Measuring Light

Light meters measure the amount of light in a scene and help you determine the correct settings for an accurate exposure. Some cameras have settings that work automatically to find the exposure without your involvement. These settings—such as fully automatic, shutter priority, and aperture priority—take into account the film speed, aperture, and shutter speed, selecting a combination calculated as ideal for the amount of light sensed. With other cameras, you can participate in the decision by using manual settings to override the camera's settings. Light meters are commonly built into a camera. There are also separate light meters, called handheld meters, which are used by many professionals to fine-tune the process of measuring light.

Light Meters Can Be Fooled

Be forewarned. If the light is fairly even throughout your picture, light meters work especially well to give you an accurate reading. But if there are extremes in the scene, with both very dark and very light areas, a light meter may not give an accurate reading.

A light meter can't know what part of the picture is important to you. It can't know which area should dominate the light measurement. It measures the light in the area of the picture where you point the light meter. Though light meters are designed to assess the light *throughout* the photo (sometimes called matrix metering), usually there is a somewhat heavier weight given to the center of a photograph. In the viewfinder of many cameras, you can see a center circle, which is the prime area of measurement.

The classic example of this problem is when you have a person in front of, or near, a bright light source. If your child is sitting near a bright window, the light meter will read the brightness of the window light. If you rely on one of the camera's automatic settings, the camera will adjust accordingly to allow in less light. This will make the photo darker, so the window area is correctly exposed. But then the details in the eyes and the skin tone on your child will be much too dark. Unless you intend the photo to be a silhouette, it's most likely you want the skin tone of the child correctly exposed and let the window go too light. The light meter has no way of "knowing" that information.

There are several solutions to the problem. One is to move the child slightly or change your own position so the window makes up a smaller portion of the frame. This should give the light meter a reading for correct exposure on the child. If your camera allows for manual adjustments, the standard practice is to simply let the light meter read the light on your child, manually adjust the exposure to that reading, and then take the picture.

If your camera is fully automatic, you don't have that option, though in some of the better automatic cameras there is an exposure-lock button. This allows you to meter the child, press the exposure-lock button, and then reposition the camera to your original composition.

Another technique is to use flash to balance the light on your child with the light from the window. The danger is that if the window is closed, your flash will most likely create a distracting reflection in the glass. Also, using the flash actually kills the gentle quality of the

window light. (Aside from metering considerations, in this situation I like to turn the child 45 degrees to the window to obtain the sidelight I prefer.)

The difficulty of correct metering can occur outdoors as well. Suppose you have put your child in the backyard for a photo. In the background to the left is a bright white wall of a house. To the right is a dark area of dense green bushes. The contrast in light is just as extreme as by the indoor window. Your solutions are the same. Move your subject, or adjust the exposure manually. For an example, go back to see the photo of the Clarke baby by the door in 3-6. On that occasion I measured the light outside the door and let the baby become dark for an intentional silhouette.

Shutter Speed

The shutter mechanism opens and closes the shutter and controls how long it stays open. The time the shutter stays open is very significant. The time the shutter stays open is measured in fractions of a second. Shutter speeds go from very fast (1/8000 of a second on some cameras) to very slow (seconds and even minutes). There are also ways to keep the shutter open for very long periods of time—this is useful when photographing at night, for example. You'll probably find that the most useful shutter speeds are in the middle of the range, such as 1/60th, 1/125th, and 1/250th of a second. Just remember that shutter speed is the partner with aperture for controlling exposure. It's part of the equation.

Letting Light In

The length of time a shutter is open affects the amount of light that the film or digital sensor receives. If the shutter stays open a long time, it lets in more light than when it closes quickly. To get a feeling for the speed of a shutter, listen to the sound of the shutter at various settings. At a quarter of a second there is a "kerplunk" sound as it opens and closes. If that isn't obvious enough to you, try setting the shutter at half a second. Then switch the shutter to 1/500th of a second—you can barely discern the sound, it happens so fast.

To sum up, exposure is the relationship of lens aperture and shutter speed. Aperture and shutter speed are the yin and yang of exposure. It will sink in suddenly and it's like riding a bike: Once learned, it will always be with you.

Stopping Action and Eliminating Camera Shake

Beyond exposure control, the other significant effect of the shutter speed is in the ability to freeze action and eliminate camera shake.

Shutter speed controls the stopping of action. The faster the shutter speed, the faster the action that can be stopped. The slower the shutter speed, the less likely that action will be stopped and that your subject will be blurry.

Another cause of blur is camera shake, caused by hand movement. The slowest shutter speed that is considered safe to handhold your camera without getting blur is 1/60th of a second for a normal lens. Longer lenses, as you'll see later, require a faster shutter speed to avoid camera shake. Handholding a camera is always subject to hand movement, but higher shutter speeds compensate for this. Experienced photographers, who know to steady themselves on

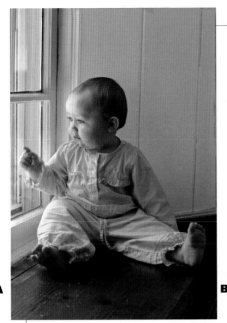

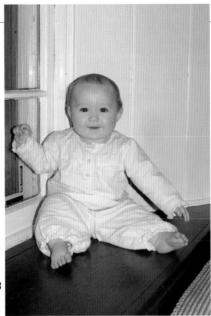

A

B

There are times when flash is the only answer, and a good one. In photo C, of Darcy in the bath, flash was essential because it was the only light source and it works perfectly in this situation.

C

[11-7] In photo A, without a flash, the natural window light gives modeling to Darcy's skin and clothes, which I find pleasing. The on-camera flash in photo B provides a clear view of Darcy's face and eyes. It is a nice snapshot. But it also illuminates more detail of the windowsill than you need, and there is almost no subtlety to the light. Her clothes are bleached out, her face tone flat.

a doorjamb, tree, or wall, can get sharp results at 1/30th of a second and slower when using normal and wide-angle lenses. But for safety's sake, at slow speeds such as 1/30th of a second or slower, a tripod is recommended to avoid blur from handshake. But since children don't stay still, a tripod may eliminate camera shake but will be of little help in keeping a child's face from blurring due to motion. There are photo examples of stopping action in chapter 7.

Film

As anyone who has done photography knows, there are many types of film available. Films are formulated to accommodate different types of lighting conditions and to provide varying styles of color balance. Most digital cameras have settings to approximate these variables. In terms of exposure, film is the third, and sometimes less credited, partner in the exposure equation, along with aperture and shutter speed.

Film Speed

The words "speed" and "fast" keep popping up in photography relating to lenses and shutters. Now here they are again. This time, "speed" is used in connection with film. The speed of a film, called an ISO rating, relates to the amount of light needed to create a usable image.

A

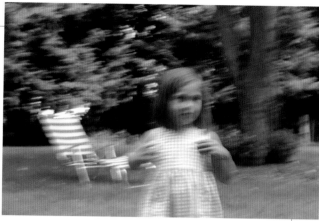

B

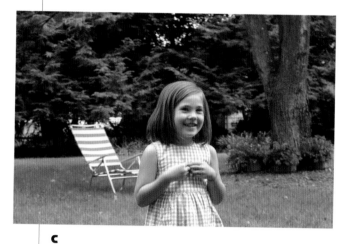

C

[11-8] In diagnosing blur, check to see what portion of the photo is blurry. In photo A of Jessie, she is blurry but the lawn chair and tree are sharp. What happened? We focused on the wrong spot (or the auto-focus did). The focus is on the lawn chair, not on Jessie. Another clue is the background. It isn't blurry, which means we used fast enough shutter speed to eliminate camera shake. In photo B, everything, both Jessie and background, are blurry. This blur comes from using a slow shutter speed. There is motion by the child and motion from my hand, which cannot hold the camera steady at the slow shutter speed 1/30th of a second. These cause blur in both subject and background. Notice the way the tree leaves in back seem streaked from motion. Finally, photo C is sharp because focus is correct on Jessie, plus the shutter is fast enough to keep both her and the background from blurring.

Film speed is the third factor in calculating exposure (along with aperture and shutter speed). Digital cameras have settings that simulate film speeds, or ISO ratings.

If a film needs a lot of light to get a correct exposure, it is termed a *slow* film. Slow films carry an ISO rating of 50 to 100. A medium speed film is ISO 200. Fast films range from ISO 400 to 3200. The higher the ISO rating, the less light you need for an exposure. There is, as always, a catch. With color films, the slower films have richer colors, greater resolution, and lower grain. The faster films are less rich in color and have a grainy, less-sharp appearance. You might use an ISO 100 film outdoors in bright light. Use an ISO 200 film indoors near a window. Use an ISO 400 film on a cloudy day or for action. Use ISO 800 or 3200 film inside a gym during a volleyball game. Remember that digital cameras provide the same ISO settings.

The old timers in photography (and early photo books) often referred to the "Sunny 16" rule: In bright sunlight for a front-lit subject, you use f/16 and the reciprocal of the film speed as your shutter speed. So for example, with an ISO 64 film, you'd use 1/64th of a second shutter speed at f/16. For ISO 400 film, you'd use 1/500th of a second at f/16, and so on. It's amazingly accurate much of the time.

Diagnosis of Blur

It can be puzzling and disappointing when your photos turn out blurry and you aren't sure what went wrong. What you see as blurry actually might be one of three conditions: blur from subject movement, blur from camera shake, or poor focus.

Blur caused by subject movement is due to the shutter speed's not being fast enough to catch the action of a fast-moving subject. To solve this, you should increase the shutter speed to a speed fast enough to stop the action—a speed such as 1/250th, 1/500th, or 1/1000th of a second. But this is only possible if there is enough light to allow the fast shutter speed. There are times when it is simply too dark to stop action well. Another solution is to use a faster film speed, so that the lower light is less of a factor.

To eliminate the effect of camera shake, use a shutter speed that matches (or exceeds) the reciprocal of the focal length of your lens, or 1/focal length. For example, if you are using a 50mm lens, use a shutter speed of 1/60th of a second or more. For a 200mm lens, use 1/250th of a second.

Blur can also be caused by poor focus. If you don't focus on the main subject, it will appear blurry or soft-edged.

There are times when the blur is a combination of factors: your shutter speed is too slow because of low light *and* you aren't focused on your subject. To figure out what might have gone wrong in a blurry photo, check first to see if everything is blurred. That might indicate a shutter speed is too slow to eliminate camera shake. If something in the foreground or background is clear and sharp but your subject isn't, then most likely the lens isn't properly focused on the subject or the subject was moving.

Flash

Many cameras come with a built-in flash. A flash is a useful tool for filling in shadows on a bright day or to help add light to the face in a backlighted portrait. Of course, for getting a good snapshot in a dark area, a flash is essential. There are drawbacks to using on-camera flash. It can create a flat light that shows the subject clearly but removes all mystery and mood from the lighting (as we showed in chapter 5).

One point to check when buying a camera is if the flash comes on automatically or if you have the option to turn the flash off. There are times when you want a lighting mood that would be killed by a flash. A good camera dealer can tell you if the camera you are considering has a way to turn off the flash. For those who want to extend their photographic skills a bit, using a small off-camera flash can be very effective as a fill light.

Red-Eye and Its Cure

With an on-camera flash, you risk the problem of red-eye in your subjects. If you get red-eye, there are two ways to remove it after the fact. It's easy to remove the red using Photoshop® or other digital retouching software. For those who get color prints from a color negative and don't work with a computer, the old tried-and-true retouching pencil for red-eye is still available at some photo retailers.

Avoiding red-eye in the first place is possible if your flash is off camera, at an angle to the subject. Most of the newer consumer cameras have a red-eye reduction feature in the

flash unit that flashes a preliminary light intended to close down the pupil of the subject (so the red won't show), prior to the flash that actually exposes the picture. This feature can be a double-edged sword. It usually cures red-eye, but the delay between the preliminary light and the real flash can be as much as several seconds. The result is you don't get what you see. You get a picture of the expression a few seconds after you press the shutter. I find this very frustrating when you are trying to capture a spontaneous moment.

Digital Versus Film

So, should you stay with a film camera or convert to a digital system? If you are planning to buy a new camera system and have grown up with computers, I will tilt the scales right now toward suggesting that you go with digital. Even if you are leery of technology, don't go backward. Digital camera technology has become universal and manageable, as well as a lot of fun. Within the next five years, it should become even easier. It is not necessary to have a high level of computer literacy either, so that shouldn't present a stumbling block. However, if you are not comfortable with the computer or want to spend the least amount of time in the processing of the pictures, then a film camera may be your choice. Film cameras are familiar and reliable, and the results are of predictably high quality.

Digital Cameras

A digital camera works in many ways like a film camera. All the photographic concepts are the same. The key difference is that instead of recording the image on film, it records information on an electronic sensor, which then transfers the information to a memory card. This memory card stores the information (your photo) as a digital file. The picture is digital information instead of chemically treated plastic.

Pixels

A digital picture is captured on a sensor made up of tiny dots called picture elements, or pixels. The maximum number of pixels in the image indicates the quality of a digital camera. The more pixels, the more detail and sharpness, and the bigger you can enlarge the image. Digital cameras are rated in terms of the number of pixels in their sensors, and this number is given as megapixels (one megapixel equals one million pixels). The number of megapixels they deliver is the primary question asked about today's cameras. Each month, new cameras come out with more megapixels at lower prices. A three-megapixel camera was considered in the upper range not too long ago; now it is entry-level quality. This will continue to change as prices come down, and quality and features improve.

How Digital Photography Works

▶ Shoot the photos (as many as your card will hold)
▶ Remove the memory card
▶ Transfer the information from the memory card to a computer; directly to a printer (if your printer has the capacity to accept memory cards); a device attached to your

TV set; a photo store or one-hour lab, where they will make prints; or a CD, where you can store the images until needed—use either the files on your computer or take the memory card to a photo store

▶ If you have the digital files transferred to your computer, the next task is to edit, process, and print them. You will need to own and learn to use editing software, retouching software, photo-manipulation software, and a photo-quality printer

Making a Camera Choice

Finally, back to where we started. Making a camera choice:

▶ Do you want a film camera or digital?
▶ What is your price range?
▶ What features do you want or need? Close up lens, zoom lens? Put another way: what's giving you trouble with your present camera?
▶ What level do you want to be at: amateur, intermediate, advanced?

Shopping

Before shopping do some research. If you are a photography buff, there are a variety of magazines such as *Popular Photography & Imaging* that periodically reviews new cameras. Another excellent source for research is *Consumer Reports,* since it is consistently clear, thorough, and unbiased (*www.consumerreports.org*). If you need more technical details on equipment you are considering, go to the camera manufacturers Web site. And among the major online photo sources are *www.adorama.com,* and *www.bhphotovideo.com* (and also Amazon.com), which will have detailed listings and competitive pricing.

Once you've narrowed down to three or four camera models, go to the professional photo dealers rather than a neighborhood shop. Professionals handle a wide range of cameras and will be able to advise on technical as well as practical issues. In addition, you can feel how the camera handles. Are the dials easy to find? Is it comfortable in your hands? An additional advantage of buying from a good professional stores is the follow up they offer such as diagnosing a problem, for example, with photos that aren't properly exposed. Online prices may be attractive but you won't get the personal service.

This chapter has given an overview of the basic technical points of photography. For those who want to move well beyond their current skill level, I recommend taking a photography course where you do can get hands on experience working with the constructive criticism of an instructor.

If you can't spend time on a course there are helpful technical books such as one I recommend most highly, *Mastering the Basics of Photography* by Susan McCartney. Susan is a professional photographer who has a knack for giving complete, detailed information in clear, concise language.

The primary reason for understanding the technical aspects of photography is simply so you can make your photos of your children more pleasing.

Creating a Lifetime Photo Record

You'll cherish having good photographs of every stage of your child's life. So take time each week, or at least every month, for a photo session. Add more to your cherished memories by including family members, catching the tender moments of their interaction with your child.

I wish you great joy in the photographing of your children.

 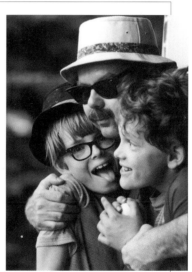

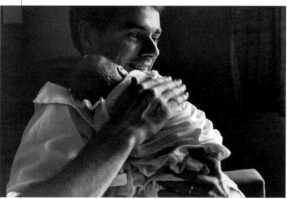 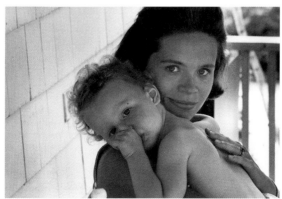

Index

Books from Allworth Press

Allworth Press is an imprint of Allworth Communications, Inc. Selected titles are listed below.

Mastering the Basics of Photography
by Susan McCartney (paperback, 6¾ × 10, 192 pages, $19.95)

Photographic Lighting Simplified
by Susan McCartney (paperback, 6¾ × 9⅞, 176 pages, $19.95)

How to Shoot Great Travel Photos
by Susan McCartney (paperback, 8½ × 10, 160 pages, $24.95)

Mastering Nature Photography: Shooting and Selling in the Digital Age
by John Kieffer (paperback, 6 × 9, 288 pages, includes CD-ROM, $24.95)

Creative Canine Photography
by Larry Allan (paperback, 8½ × 10, 160 pages, $24.95)

Mastering Black and White Photography, Revised Edition
by Bernhard J Suess (paperback, 6¾ × 9⅞, 256 pages, $19.95)

Creative Black-and-White Photography: Advanced Camera and Darkroom Techniques, Revised Edition
by Bernhard J Suess (paperback, 8½ × 11, 200 pages, $24.95)

Photography: The Art of Composition
by Bert Krages (paperback, 7¾ × 9, 256 pages, 250 B&W photos, $24.95)

Pricing Photography: The Complete Guide to Assignment and Stock Prices, Third Edition
by Michal Heron and David MacTavish (paperback, 11 × 8, 160 pages, $24.95)

How to Shoot Stock Photos That Sell
by Michal Heron (paperback, 8 × 10, 224 pages, $19.95)

Stock Photography Business Forms: Everything You Need to Succeed in Stock Photography
by Michal Heron (paperback, 8½ × 10, 144 pages, $18.95)

Starting Your Career as a Freelance Photographer
by Tad Crawford (paperback, 6 × 9, 256 pages, $19.95)

Photography Your Way: A Career Guide to Satisfaction and Success, Second Edition
by Chuck DeLaney (paperback, 6 × 9, 304 pages, $19.95)

Please write to request our free catalog. To order by credit card, call 1-800-491-2808 or send a check or money order to Allworth Press, 10 East 23rd Street, Suite 510, New York, NY 10010. Include $5 for shipping and handling for the first book ordered and $1 for each additional book. Ten dollars plus $1 for each additional book if ordering from Canada. New York State residents must add sales tax.

To see our complete catalog on the World Wide Web, or to order online, you can find us at ***www.allworth.com.***